White Bears
and other curiosities . . .

White Bears
and other curiosities . . .

*The First 100 Years of the
Royal British Columbia Museum*

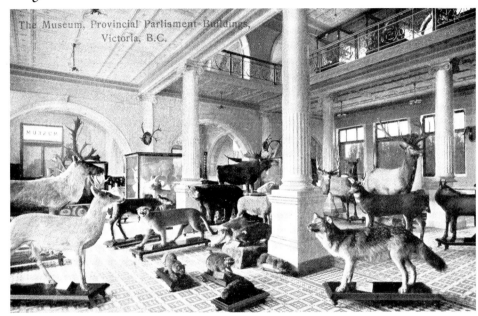

*A hand-tinted postcard of the
Museum in the first decade of this
century.*

Author
Peter Corley-Smith

Art Direction and Design
Chris Tyrrell

Illustrations
David Lloyd Glover
Rennie Knowlton (Cover)

A Royal British Columbia Museum special publication produced by
the Friends of the Royal British Columbia Museum in association
with Crown Publications Inc. and the Ministry of Municipal Affairs,
Recreation and Culture, 1989

**ROYAL
BRITISH
COLUMBIA
MUSEUM**

Canadian Cataloguing in Publication Data
Corley-Smith, Peter, 1923–
 White bears and other curiosities

 (Royal British Columbia Museum special publication ISSN 0840–7681)

 ISBN 0–7718–8740–X

 1. British Columbia Provincial Museum. I. Royal British Columbia Museum.
II. Title. III. Title: First 100 years of the Royal British Columbia Museum. IV.
Series.

AM101.V52C674 1989 069′.09711 C89–092057–5

Dedication

This book is dedicated to John, "Jack" Fannin, a man of many talents and the Museum's first Curator. He left us a firm and enduring foundation on which to build.

Foreword

William Barkley

The Royal British Columbia Museum is more than 100 years old. What does this mean? It means that the Museum as an institution has survived for more than a century and, therefore, that its successes must have exceeded its failures. It means that it has met the needs of British Columbia's culture and society for 10 decades. It has an excellent chance of surviving and succeeding in the next 100 years.

This book examines the first 100 years of the Museum. The story is a story of people. People who saw a need in the still-new community called British Columbia. People who had a vision of how the past could be preserved for people of the present and the future. People who had the imagination and creativity to present the past to several generations of British Columbians and their guests.

As the Director of this institution, I welcome the opportunity to continue a tradition of achievement in preservation, collection, research and public programming. My predecessors, Fannin, Kermode, Carl, Foster and Edwards, met the challenge of piloting this museum through times of opportunity and of crisis. They have left me a solid legacy on which I will build.

There are many people who will remain anonymous in the account that is to follow. Among them are the thousands of volunteers who gave, and continue to give, their time for no financial reward. They provide help whenever it is needed. They perform mundane tasks that have to be done and they perform sophisticated and complex tasks that no one else can do. These people are a testimony to the importance of this institution to British Columbians.

The generations of staff who have filled a wide array of positions over the 100 years were, and are, dedicated people. They work for long hours and low pay. They have shown, over the generations, a remarkable dedication and enthusiasm for their work. The people who have worked at the Museum over the years are a remarkably creative, imaginative and dedicated group of people.

I have no hesitation in predicting that the next 100 years will record successes of this museum beyond our current imagination. The Royal British Columbia Museum has entered its second century from a position of strength. The Museum is the most popular museum in Canada and, as an institution, has had the courage to put its purposes and methods of operation up for critical review and change. Anyone who has been associated with this museum remarks on the potential still unrealized. This potential provides the opportunity for future successes. The next 100 years will be exciting for both the observer and the participants.

Bill Barkley

1989

Preface

At the outset of any written history, the author is faced with a multitude of choices. In the case of a museum, he or she has to decide, for example, whether people are more important than the collections — or of course, whether both should be dealt with. The list grows like a spring vine. What about research, interpretation, display techniques, conservation, cataloguing? — a host of possibilities looms up and the whole project begins to assume unmanageable proportions.

In this book, itself one part of the events and projects to mark the British Columbia Provincial Museum's 100th birthday, the decision was made to celebrate the people who founded the Museum and the people who kept it alive through wars and depressions, as well as those who helped to make it prosper and grow in the good times. While this simplified the task — we could now proceed with a chronological narrative, digressing when necessary to the various aspects of a museum's activities — in another sense it became more difficult. If one is unfair to techniques, little damage is done; if one is unfair to people, the responsibility is much more pressing.

Fortunately, we were able to call on the help of exceptionally competent researchers in our search for that elusive commodity, the truth. Richard S. Mackie spent long months in the Provincial Archives and the Legislative Library assembling the basis of our narrative. When he returned to his studies at the University of British Columbia, his place was taken by an equally diligent and meticulous researcher, Megan Davies. If there is any misreading of documents, therefore, or failure of interpretation, the fault must lie with the author.

In addition, we have been able to turn for help to several people who themselves were part of the Museum's history. Dr. Josephine F. L. Carl, Dr. Adam F. Szczawinski, Charles J. Guiguet, Dr. Ian McTaggart Cowan and Dr. W. Kaye Lamb all gave generously of their time in interviews and with suggested improvements at the manuscript stage. They were able to solve some of the ambiguities posed by old, hurried memos and other official documents and, we hope, breath life into the accounts of the people with whom they worked in the Museum.

We thank them for their part in making the British Columbia Museum what it is, and for helping us to celebrate its 100th anniversary.

Contents

A Growing Anxiety

Consolidation

Crossroads

The Clifford Carl Years

A Growing
Anxiety

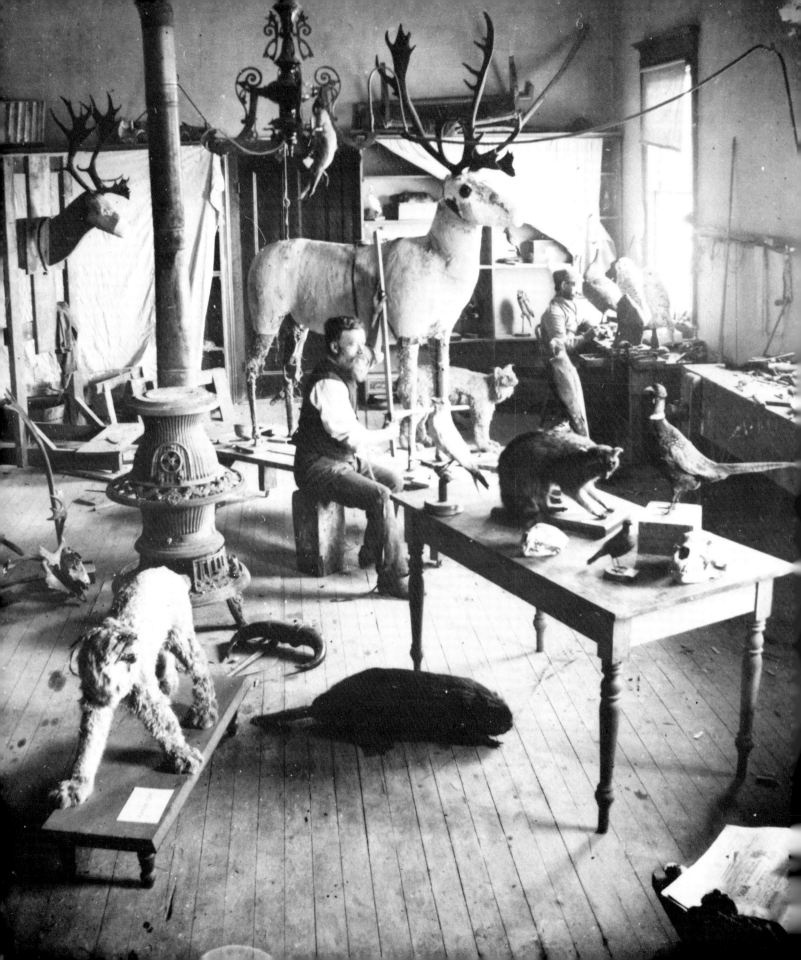

A Growing Anxiety

". . . Prominent Persons, Scholarly or Otherwise . . ."

Some of the influential people who signed the petition to found a museum: (Clockwise from top left) George A. Walkem, Matthew Baillie Begbie, William Fraser Tolmie and John A. Mara.

By modern standards, the genesis of the British Columbia Provincial Museum, originally called the Provincial Museum of Natural History and Anthropology, unfolded with remarkable crispness and despatch. On the evening of January 14, 1886, a group of 30 citizens held a meeting in Victoria. They were influential people; among them were names like Begbie, Rithet, Crease and Tolmie, all of whom achieved distinction in the Province: Begbie as a judge, Rithet as a mayor of Victoria and Member of the Legislative Assembly, Crease as a Member of the Legislative Assembly and cabinet minister and Tolmie as a physician, botanist and anthropologist (his son became Premier of British Columbia in 1928). The purpose of their meeting was to prepare a petition to the Provincial Government, urging the government to create a museum. They were motivated by a growing anxiety that collectors commissioned by museums in the United States and Europe were rapidly exporting the majority of the artifacts representing the cultural heritage of the native peoples in this province.

The petition was presented to Clement Cornwall, the incumbent Lieutenant-Governor, on January 16. He promptly forwarded it to the Cabinet, known then as the Executive Council, with a strongly worded personal recommendation for approval, pointing out that the petitioners were "the most prominent persons, scholars or otherwise, in the place."

Two extracts from this interesting document (reproduced in full as Appendix I) are worth quoting here. The first proposed that the objective for the museum would be, "to preserve specimens of the natural products and Indian antiquities and manufactures of the Province and to classify and exhibit the same for the information of the public."

. . . the petitioners were "the most prominent persons, scholars or otherwise, in the place."

. . . it is therefore earnestly desired that geological and natural history specimens from all parts of the province may be collected by those who have the opportunity, and forwarded to the Curator . . .

As an objective for a museum, this statement has stood the test of time admirably. Yet there is one interesting omission: no mention is made of what is now considered one of the principal functions of a museum — collecting.

This may, of course, have been a simple mental lapse; an assumption that the word *collecting* was so obvious in this context it need not be specified. But there are grounds for suspecting that it was deliberate. The petitioners visualized the museum as a simple repository for material collected by others. Who, then, would these others be? For a possible answer, we need to remember that, until the early years of the twentieth century, the word amateur had no negative connotations. It did not suggest lack of expertise; on the contrary, the best athletes in the world were all genuine amateurs. Similarly with science: it was not a profession, but a calling. Research wasn't conducted by salaried Ph.D.'s, specializing in narrow fields. It was the realm of the gifted amateur; a person, usually an aristocrat, with the leisure to conduct research and the means to embark on collecting expeditions — or, if not, somebody who, like the artist, found a wealthy patron to support him while he worked.

An obvious example comes to mind with perhaps the most celebrated collecting expedition in British Columbia's history: Captain Cook's voyage to the northwest Pacific in 1778. The entire scientific element of this expedition was subsidized by Joseph Banks, later *Sir* Joseph and President of the Royal Society, who paid a large part of the expenses out of his own pocket. As a matter of record, the majority of the specimens collected by Banks and his assistants were lost within a few years after the return of Cook's expedition because there was no repository available with the means to preserve them.

Some support for the assumption that collecting was not envisaged as a staff responsibility comes at the end of a brief description of the Provincial Museum in the British Columbia Directory for 1892.

> The co-operation of the general public is necessary to insure the museum becoming a really representative institution; it is therefore earnestly desired that geological and natural history specimens from all parts of the province may be collected by those who have the opportunity, and forwarded to the Curator

With regard to Indian curios, it is much to be regretted that so many are being exported from the Province. The funds at the disposal of the museum are quite inadequate to meet the high prices demanded by the dealers, so that it is to be hoped all who can will assist in securing, rare specimens, and that persons visiting the outlying districts will avail themselves of their greater facilities for bartering with the Indians, and add to the, at present, somewhat meagre collection now in the museum.

Whether or not these considerations were in the minds of the original petitioners, we all owe a great deal to the amateur collectors and scientists. While the system lasted, it was an admirable one. The wealthy felt they were returning something to society; the less fortunate did in fact benefit. The amateurs covered wide areas of scientific research, and it was only when they had done the ground work, when their collections had grown to impressive proportions, that we had to change our ways. Because of them, the body of knowledge expanded beyond the bounds of the gifted amateur, and it became necessary for society to begin hiring trained, professional scientists.

The second extract from the petition is interesting for another reason — an enduring one: the necessity to persuade the politicians and the public that a museum is valuable to society as more than an entertaining, or even an aesthetic experience. A justification was required. The petitioners wisely provided just such an example:

There is no doubt that the recent opening-up of British Columbia by railway enterprize will stimulate the development of her mineral and other natural resources; hence a museum where classified specimens of ores, etc. may be examined will prove of practical benefit to the Province at large.

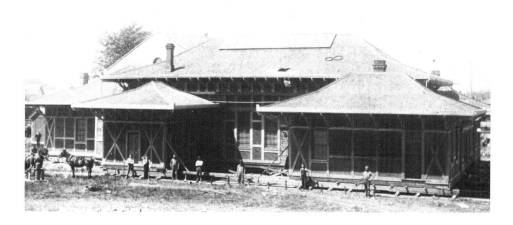

Christened, with a mixture of irony and affection, "The Birdcages," the original Legislative Buildings housed the first Museum. It was located in a small room next to the Provincial Secretary's office.

Approved
Clement Francis
October 25th 1886.

There is a touch of irony here, because the mineral collection was passed over to the Department of Mines only four years later and, to this day, the Museum has never had a geologist on staff. Nevertheless, the validity of the statement has stood the test of time, and it needs to be repeated regularly if museums are not to be regarded as expensive luxuries that society can only afford in times of great prosperity. A good museum provides much more than entertainment, or even education; it offers, as we shall see, many and varied advantages to society.

The Executive Council, like the Lieutenant-Governor, was quickly persuaded that the province needed a museum. The gestation period may or may not have been symbolic, but a little over nine months after the petition was presented, the Provincial Museum of Natural History and Anthropology opened on October 25, 1886. It was housed in a 15- by 20-foot room next to the Provincial Secretary's office in the old Legislative buildings known as the "Birdcages".

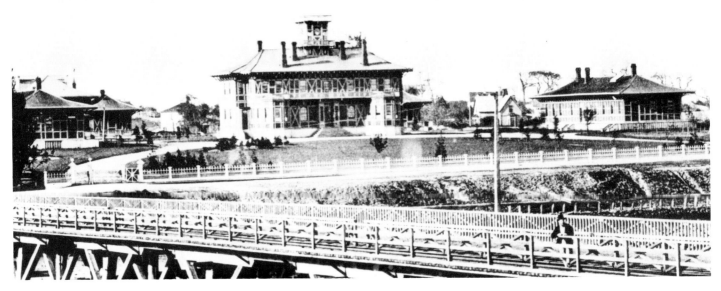

"The Birdcages," photographed from the north bank of James Bay.

20

A Man of Many Talents

*I*n the meantime, of course, the government had had to look for a suitable person to run the new institution. The choice seems to have been a relatively simple one and it was unmistakably successful. John Fannin, almost invariably referred to as Jack, the Museum's first Curator, was a man of many talents and an extremely interesting character. Before describing his career, however, we should make a point that will probably occur to the reader sooner or later. For the first 70 years of its history, staffs were so small that the Museum and its director were virtually synonymous; this was particularly so in the case of Fannin. It was only in the 1950s that other staff began to make their influence felt.

Fannin was born in Kemptville, Ontario, on July 27, 1837. We know little about his early life, except that he taught school in Kemptville (and the evidence for this claim is suspect). In 1862, when he was 25 years old, the lure of gold tempted him, as it did so many other young men of his generation. Gold had been found in the sandbars of the Fraser River. Eager prospectors and miners worked up the river, finding gold all the way up to Quesnel Forks, where they branched off to follow it up the Quesnel River, eventually discovering Williams Creek — on which the town of Barkerville sprang up — and precipitated the Cariboo gold rush. By the time the news reached Kemptville, the richness of the finds had no doubt been magnified many times.

Fannin decided to join a party of Overlanders; as he would discover, he was going to travel to what we now call British Columbia the hard way. The party, led by Thomas McMicking, left Queenston, Ontario, on April 23, 1862 and reached Fort Edmonton on July 21. At Tête Jaune Cache, the party divided and the group Fannin joined struck across country towards the headwaters of the North Thompson River. After what were tersely described as "frightful hardships" they reached the Thompson and continued their journey by canoe and raft, arriving finally at Kamloops on October 11, 1862. It is recorded that Fannin's raft capsized and he lost all his possessions and nearly his life as well.

Jack Fannin spent the next eight years seeking his fortune, first around Barkerville in the Cariboo, later in the Big Bend area of the Columbia River. In addition to his mining and prospecting activities, Fannin spent some time as a rancher in the Kamloops area. By 1870, he decided to settle down and set up as a shoemaker in New

John Fannin, almost invariably referred to as Jack, the Museum's first Curator, was a man of many talents and an extremely interesting character.

John Fannin "relaxing" with a friend. It was difficult to strike a natural pose while sitting perfectly still for the slow shutter speeds of the 1880s.

Westminster (which seems a surprising occupation for an ex-schoolmaster to turn to); but the next move seems even more surprising for a shoemaker: he was appointed as a provincial government surveyor and sent, in the summer of 1873, to ascertain "the character and area of unoccupied lands in the valley of the lower Fraser." His report was published the following year and obviously satisfied the government, because he was then commissioned to do a survey of the upper "Stickeen" River.

As might be expected, this survey turned out to be much more arduous than the one in the lower Fraser valley. For the second time Fannin came within an ace of losing his life. Travelling by steamer to Wrangell, Alaska, early in November, 1874, he intended to reach Glenora, a small settlement which was later superseded by Telegraph Creek just to the north of it. There he planned to winter before continuing his survey the following summer. Too late for the steam navigation season, he made two false starts by canoe; dangerous ice flows were sweeping down the river and the Indians in the party refused to take the canoes any further. Finally, on December 5, he set out again, determined to cover the 60 miles to Glenora on foot. He was assured that the ice was now solid and he reasoned that it was too early in the season for the snow to cause any problems.

John Fannin measuring and recording the size of a handsome elk in the Museum's second home: the former Courthouse.

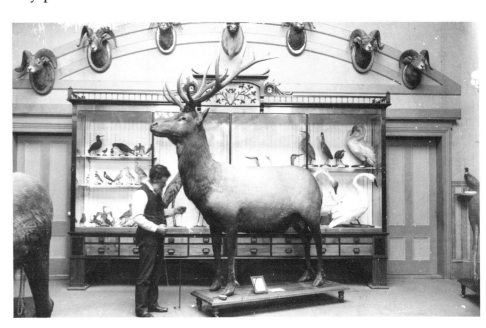

His party on this occasion was limited to himself and George Florrence, described as an experienced young French-Canadian woodsman. Hauling food and supplies for eight days on a sled, they estimated that they could cover the 60 miles to Glenora in four days. However, on the second day out, a storm, which Jack Fannin later described as the fiercest and most prolonged in his experience, began. For the next 15 days, they pressed on into a blizzard, alternating as trail-breakers, their snowshoes sinking into the thickening snow. On the 12th day the last of their food was gone. Finally the storm eased and now, for the first time, they could see far enough to identify some landmarks in the surrounding mountains. They were less than halfway to their destination.

Not surprisingly, young Florrence counselled returning to Wrangell as fast as possible. Instead, Fannin decided to abandon the sled, including their blankets, and make a determined attempt to reach Glenora. Armed only with an axe, they set off again, trying to get a couple of hours of sleep around a campfire at night. They persevered but, on the third day, came to an impassible obstacle — a gorge with open water from bank to bank — and the banks were perpendicular bluffs. Florrence finally persuaded Fannin to turn back. Weakened by lack of food and the cold, their chances of survival seemed remote. That night, when Fannin was talking to his companion, trying to keep him awake so that he wouldn't freeze to death, young Florrence collapsed into the campfire. Luckily, he was uninjured. The following day, as they were travelling past an open slough, Florrence suddenly took off his snowshoes and plunged into the water, emerging a few seconds later with a salmon grasped "so tightly," as the *Daily British Colonist* reported, "that his fingers met through the fish."

The *Colonist* continues:

> The salmon lasted them 5 days. They reached their blankets, and taking one each they kept on down the river. On . . . Christmas Day they reached that point of the river where the ice is broken up by the action of the tides. They were still five miles from Wrangel[l]. Here they constructed a raft and at dark embarked, but ran only about a mile when the raft struck a rock, and Fannin was swept into the tide. He, however regained the raft, when they concluded to go ashore and build a fire The next day was spent in building a more substantial raft with which they might cross the gulf to the Island, as there was no telling when they might hail a canoe. It was nearly dark as they were ready to start, when just as they stepped aboard, an Indian with a canoe came to their rescue.

. . . Florrence suddenly took off his snowshoes and plunged into the water, emerging a few seconds later with a salmon grasped "so tightly," as the Daily British Colonist *reported, "that his fingers met through the fish."*

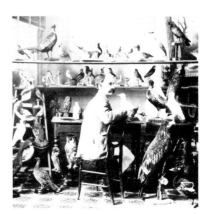

Albert A. Maynard, a member of the British Columbia Natural History Society, and probably the first Museum volunteer, prepared bird specimens.

After this ominous brush with the elements, we are not surprised to hear that the cobbler returned to his last. Fannin set up as a custom shoemaker in the little community of Hastings, on Burrard Inlet, and became its postmaster as well. By now, too, he had developed an interest in nature beyond the simple search for minerals; he had become an amateur taxidermist and collector, supplementing his income by guiding hunting parties to Howe Sound and Knight Inlet. On one occasion, he acted as guide to a party of New York sportsmen on "A trip to the Bighorn Mountains of the Similkameen," an account of which was published in the *Colonist* at just about the time he was preparing to move to Victoria to take up his appointment as curator of the new museum.

Last of the Curiosity Cabinet

The choice of Jack Fannin as museum curator almost certainly resulted from contacts he made with the wealthy and influential people he guided on hunting trips. In any event, it was an inspired choice. From all descriptions, he was a man of action, a competent

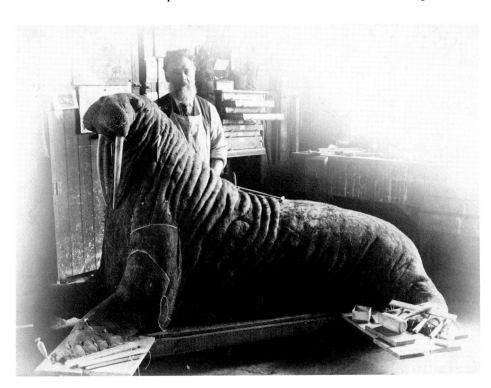

Fannin, a recognized artist in taxidermy, prepared challenging specimens like this walrus.

writer and a gifted speaker and raconteur who could relate to people from all levels of society. From a more practical point of view, he also owned a significant collection of mounted specimens of mammals and birds that he was prepared to donate to the new museum.

In a letter to Provincial Secretary John Robson, dated September 2, 1886, he advised that,"My collection consisting of 12 cases will go by the 'Yosemite' tomorrow. Better have some one to receive it and either have it stored till I come, or brought over to the building. As most of it is in glass cases great care should be taken in handling it. I will follow in a few days."

Once established in the museum, Fannin soon began to create a network of naturalists and ethnologists to steer acquisitions his way.

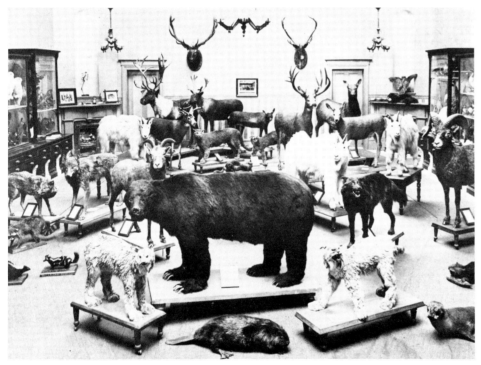

Quickly outgrowing its first quarters, the Museum was moved in 1889 to the old Courthouse which provided more room for the growing collection of mounted wildlife.

Once established in the museum, Fannin soon began to create a network of naturalists and ethnologists to steer acquisitions his way. Early in 1887, he was invited to attend a dinner thrown by some 30 of his New Westminster and Burrard Inlet friends. He was presented with a handsome gold watch and chain — a gift too valuable to be merely symbolic — as a token of their appreciation

The first regular meeting (of the Natural History Society of British Columbia) took place on April 14, 1890, at which the President delivered his inaugural address and then read the first instalment of a paper on the Salmonidae of British Columbia.

and in celebration of his new appointment. The address accompanying the gift spoke of Fannin in glowing terms. Before you read this, take a deep breath because they wrote long sentences in those days:

> . . . we ask you to wear it [the watch] as a memento of the unchanging friendship of those whose names are appended hereto, who, while regretting your separation from us, yet heartily congratulate you on your acceptance of your present position which, while offering a greater field for your ability, will fill an office in which we are proud to say no gentleman in the province is better qualified to give satisfaction than yourself.

In his reply, Fannin admitted that he had known for some time there was a surprise in store for him, "but in what shape this surprise was to come upon me I could form no idea. I had a dread that possibly it might be another lady from the east with a breach of promise case, and felt very much relieved when . . . I found out to the contrary."

If nothing else, these quotes illustrate Fannin's popularity, an asset he built on during his first few years in office. His contacts were encouraged to donate specimens and the 15- by 20-foot room rapidly filled until there was hardly space to cross it. Both Fannin's reputation and his charm must have been impressive because, in 1889, only three years after the museum opened, it was moved to more spacious quarters in the old Law Court, also in the "Birdcages" (a new Law Court had been constructed in Bastion Square in Victoria). Now, with more space at his disposal, he set about formalizing his network of amateur collectors: he was instrumental in the founding of the Natural History Society of British Columbia in Victoria.

Independent Auxiliary

The first meeting of the Natural History Society of British Columbia was held in an office in the Provincial Museum on March 26, 1890. Rules and bylaws were adopted, and the following officers appointed: President, Ashdown Green; vice-presidents, Dr. Hasell and M. de Lopatecky; secretary, Dr. C. F. Newcombe; treasurer, J. K. Worsfold; curator and librarian, John Fannin. Committee members were James Deans, Henry Wootton, Captain Devereux and J. Fielding.

A quote from the Society's constitution printed on the cover of the first annual report for the year ending March 31, 1891, makes the intention unmistakable: "The object of the Society shall be to acquire and promote a more extended knowledge of the Natural History of the Province, and to act as an independent auxiliary to the Provincial Museum". In addition, the postal address was given as the Provincial Museum.

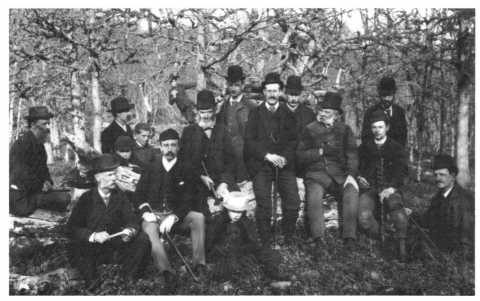

The first field trip of the British Columbia Natural History Society, Cadboro Bay, April 12, 1890. Fannin is seated, far left. Photograph by Albert Maynard.

The first regular meeting took place on April 14, 1890, at which the President delivered his inaugural address and then read the first instalment of a paper on the *Salmonidae of British Columbia.* The list of papers read during the remainder of the year is impressive — 22 topics, ranging from *The Study of Entomology,* to *The Mineral Resources of the Chilcotin Country.*

April 18	M. Danby	The Study of Entomology.
May 12	Mr. A. Green	Salmonidae of B.C. (concluded).
May 20	Dr. Hasell	Birds, What they Are.
June 9	Mr. J. Deans	The Preservation, of the Indian Remains of B.C.
June 30	Reverend P. Jenns	Leaves.
July 14	Reverend A. Beanlands	The Jade Implements of B.C.

July 28	Mr. J. Fannin	The Birds of B.C. and their Distribution.
August 25	Dr. Boas	The Skulls of the Indian Tribes of B.C.
September 8	Mr. J. Deans	The Haidah Legend of the Mountain Goat.
October	Dr. Newcombe	The Crabs of B.C.
November 3	Mr. J. Deans	Certain Myths of the Queen Charlotte Islanders
November 17	Dr. Hasell	Account of a Recent Visit to Provincial Museums in England.
December 1	Dr. Hasell	Lowest Forms of Animal and Vegetable Life.
December 29	Mr. J. Deans	Topography and Resources of the Queen Charlotte Islands.
January 12, 1891	Mr. C. P. Wolley	Bears.
January 26	Mr. A. Green	The Economic Fishes of B.C.
February 9	Mr. Danby	The Study of Entomology.
March 9	Mr. J. Fannin	The Deer of B.C.
March 23	Mr. A. L. Poudrie	The Mineral Resources of the Chilcotin Country.

In addition, a number of field trips took place during the spring and summer:

April 12	Cadboro Bay
April 26	McCauley's Point
May 10	Goldstream
June 11	Cadboro Bay
June 28	Aldemere (presumably a private residence, where the Club enjoyed the hospitality of Dr. and Mrs. Harington)
July 13	Shawnigan Lake
August 9	A dredging excursion off Victoria, Trial Islands and Esquimalt.
August 23	Beaver Lake
September 6	A dredging excursion off Sidney and James Islands
September 20	Lagoon, Esquimalt.

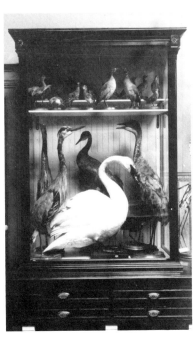

Exhibits consisted mainly of stuffed birds in glass cases and free-standing mounted animals.

28

The "Collectors" Assemble

here is a temptation to look on these early activities as examples of dilletantism. The field trips had a strong social element. Some people regarded them as not much more than an excuse for a picnic, complete with stimulating beverages, but this was a gross distortion. To appreciate their value, we must examine these activities in the context of their times.

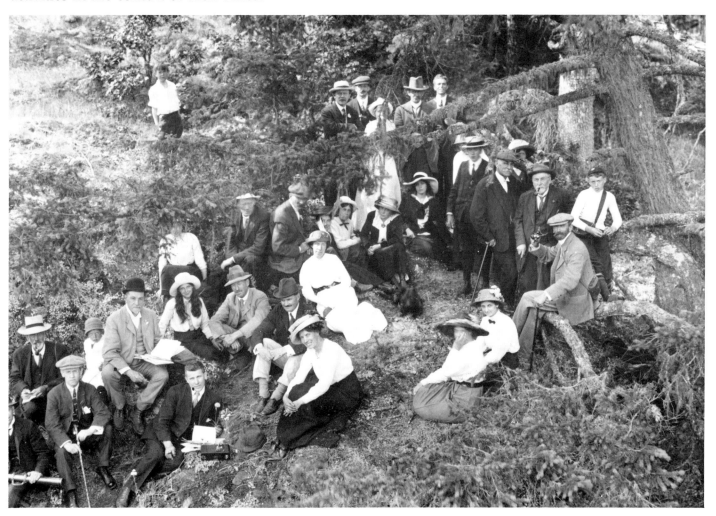

In 1900, British Columbia was still very much a frontier community.

In 1900, British Columbia was still very much a frontier community. The gold rushes of the 1850s and '60s had opened up the prospect of commercial profit unconnected with the fur trade, which had been the mainstay of all B.C. commerce until then. The construction of the Cariboo Road had moved people from the era of the canoe and the pack horse to the vastly improved mobility of the stagecoach and the freight wagon. Moreover, although few of the miners had made fortunes, many of the merchants who catered to their needs had. It was these merchants who were now seeking fresh commercial ventures to exploit.

In 1885, the last spike had been driven, completing the trans-continental Canadian Pacific Railway, another giant stride in travel and transportation through this difficult province. In 1886, the Esquimalt and Nanaimo Railway was completed. Both events added to the sense of unlimited opportunity for commercial development, and most people's thoughts and energy were focussed on trade and profit. Then, in the late 1890s, a new impetus came from the Klondike gold rush when Victoria became a major staging and supply post for the huge "stampede" to the Yukon.

The Natural History Society delved into a number of Indian burial sites on its early archaeological field trips. The patriarchal figure with the white beard is John Deans, a distinguished local biologist, anthropologist and poet.

Against this background, the value of the activities of the Natural History Society and the commercially disinterested search for scientific knowledge becomes much more apparent. People gave to it time that could have been financially valuable. The first field trip to Cadboro Bay, still very much a rural area in 1890, was to investigate rock cairns — cairns composed of large boulders which, judging by the lichen and moss covering the joints between them, had obviously been in place for many years. They were in fact burial sites and, besides the skeletons uncovered, the amateur archaeologists recovered a number of artifacts, mainly bone and wood carvings. The dredging excursions were conducted with a rowboat (though on at least one occasion a steam launch was rented) dragging a net along a sandy bottom to recover marine specimens for Fannin's collections. Because these field trips were carefully recorded, and the artifacts and specimens systematically catalogued and preserved, they were of great value to the new museum and, by extension, to the community at large — the more so because publication soon led to correspondence with other amateurs and the few professionals in the field — and eventually to exchanges of specimens.

They begged "to submit the following list of birds which, in our opinion, it will be safe to introduce into the province, viz.: Skylark, Goldfinch, Robin (red breast), Siskin, Nightingale, Blue Tit (parus coeruleus)."

"Useful, Insectivorous Birds"

Some of the Natural History Society's activities, it must be admitted, seem more whimsical than scientific. In 1900, the British element, who were very much in evidence in Victoria at the time, decided to introduce some of the songbirds familiar to their homeland. A sub-committee was formed and the provincial government was asked for funds. The legislature during the session of 1901 voted $500 with the proviso that an equal sum should be raised by the Society. Interestingly, the committee took care to justify their action by describing the birds as "useful insectivorous birds." As they put it: "Due care has been taken in the selection to see that no destructive species are introduced, but only those known to be of service to the agriculturist and horticulturist, and famous for their song." The Central Farmers' Institute was then persuaded to appoint a committee to support this venture. They begged "to submit the following list of birds which, in our opinion, it will be safe to introduce into the province, viz.: Skylark, Goldfinch, Robin (red breast), Siskin, Nightingale, Blue Tit (parus coeruleus)."

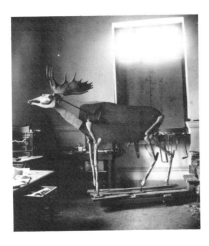

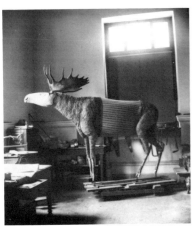

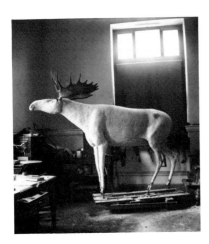

Unhappily, we now run into one of those blanks in the records; there is nothing in the files to indicate the outcome of this first endeavour. Not until 1912, when a second introduction of "useful" birds was initiated, do we hear anything of the first experiment — and then it is a brief sentence in a report from the Natural History Society's Bird Committee to the Executive: "The Committee are pleased to be able to report that the English Skylarks which were imported some years ago, are thoroughly acclimatized, as many as eight birds have been seen in the fields beyond the Jubilee Hospital on Sunday, March 14th." In any event, this second importation caused a considerable stir. When the birds arrived in Victoria, they were put on display in the greenhouses of Flewin's nurseries, and the *Daily Colonist* of January 30, 1913, reported that "Crowds Flock to See English Birds." The newspaper also reported that the deficit incurred by the Natural History Society in importing the birds had been wiped out by contributions made on the spot by enthusiastic spectators. Today, alas, there are no fields behind the Jubilee Hospital, but Skylarks can still be seen, and heard, in Central and North Saanich.

On another occasion involving birds, Jack Fannin crossed paths, so to speak, with the formidable Judge Matthew Begbie. The incident is related by W. W. Walkem in *Stories of Early B.C.*, written in 1914.

> One day a curious accident occurred to him in New Westminster when the Judge (Begbie) was shooting on a swamp at the lower end of the city. The late Mr. C. E. Pooley was with him. A snipe arose and darted off on swifly moving wings. Up went the Judge's gun: he fired, and the bird dropped. "A beautiful shot! was it not Mr. Pooley?" in which remark the latter concurred.
>
> Almost immediately after this remark was made, Jack Fannin, late curator of the provincial museum, came out of a cabin on the opposite side of the swamp, bleeding from a wound on the nose directly between the eyes. One of the shot had passed through Jack's window, and wounded him. The judge immediately went over to Jack, and with him went to Mr. Adolphus Peele, at that time a druggist, who removed the shot. On regaining the street, the judge remarked: "That was not such a beautiful shot after all, Mr. Pooley."

There is no indication of when this accident occurred, but Fannin's injury was clearly not serious, and for Victoria and the Provincial Museum, the years from 1890 to 1904 were invigorating. The Natural History Society became, not only an auxiliary to collect and donate specimens and artifacts to the Museum, but its academic arm

as well. Apart from its founders, the Society included, during these years, a highly gifted group of amateur writers and naturalists: Oregon Hastings, R. E. Gosnell, Archer Martin, Captain J. T. Walbran, J. R. Anderson, and C. C. Pemberton. These men and such guest speakers as Allerdale Grainger, W. F. Tolmie and Franz Boas contributed to the monthly programme of lectures to the Society on such subjects as archaeology, biology, forestry, botany, geology, astronomy, history, natural history, mineralogy and paleontology. These pioneers did much of the early and essential taxonomic classification of British Columbia's natural sciences. They laid the foundation for the more advanced analytical work of the mid and later twentieth century. A typical example of their work is John Fannin's *Preliminary List of Mammals of British Columbia*, published in the Society's 1893 bulletin.

Space does not permit us to do much more than mention the names of these distinguished amateurs, but one or two must be singled out because of the depth of their contributions. James R. Anderson and Chartres C. Pemberton, for example, were two leading members of the Society. Each was a second-generation member of a prominent and powerful Hudson's Bay Company family; each developed a keen and abiding interest in botany and agriculture. Pemberton studied and wrote about British Columbia's forests and Anderson started the provincial government's Department of Agriculture in the 1890s. More importantly, during his retirement, Anderson, in co-operation with Pemberton, built up the Museum's botanical collection. These early collectors were responsible for some of the first botanical collections intended for preservation within the province. Anderson also helped establish a provincial herbarium which, after 1915, was transferred to Vancouver where it became the basis of the University of British Columbia's Department of Botany under Professor John Davidson. It was also Anderson who recruited another member of the Natural History Society, S. F. Tolmie, into the provincial Department of Agriculture. Tolmie later became Premier of British Columbia. Thus, the development of the study of botany on the museum, university and provincial levels were closely linked; and they owe their origins to J. R. Anderson, a member of the Society and a Provincial Museum volunteer for many years.

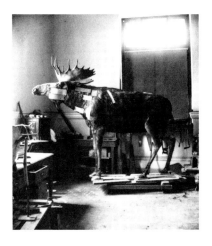

The evolution of a stuffed moose: The skull and antlers are mounted to a wooden frame. The body is sculptured. The hide is applied to the mount.

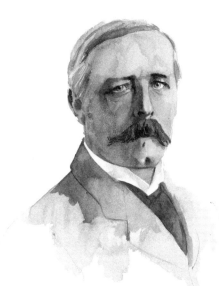

Dr. Charles Newcombe

Charles Frederick Newcombe

*H*owever, among the first slate of officers, the most celebrated by far, and for the Museum most significant, was the Secretary, Charles Frederick Newcombe who, it can be suggested with some confidence, played as large a part in the history of the museum as any of its directors.

Charles Newcombe began his career in England as an 'alienist' — the nineteenth-century name for a person who treated the insane — and ended it in Victoria as a biologist and an anthropologist, with an international reputation as a collector and authority on northwest coast Indian art.

Born in Newcastle in 1851, he earned an M.D. from the University of Aberdeen in 1878 and accepted a position as assistant medical officer at Rainhill, an asylum near Liverpool. Evidently his wife found life near an asylum distasteful, so they moved to Windermere, in England's Lake District, where Newcombe became partner in a general practice with Dr. Alexander Hamilton. While at Windermere, he took a three-month trip to Canada and the United States, travelling across the continent as far as California. He liked what he saw and decided to return so that he could explore the coast north of San Francisco. He left Liverpool on his second journey in 1883, intending to work out of Victoria. Instead, he was diverted to Hood River, in Oregon, a town so appealing that he decided to settle there and practice medicine.

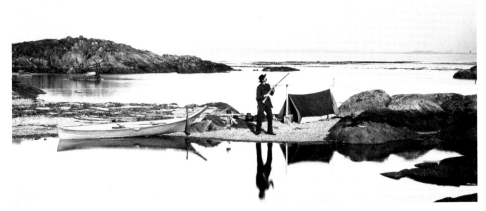

A Natural History Society "fly" camp. Before the taxidermist could practise his art, specimens had to be collected.

In 1884, he returned to England to fetch his wife and three children. The family stayed in Hood River for five years. Newcombe made a reasonable living and it was there that he, and his family, began to devote more and more of their time to collecting — principally botanical specimens and Indian arrowheads. Then, Newcombe once again abandoned an apparently successful practice and moved on to the capital of British Columbia — Victoria. There were suggestions that this move, too, may have been prompted by his wife who hoped for a more congenial climate in Victoria.

Two years after they had settled in Victoria his wife Marion, gave birth to their sixth child, a boy, and died a week later. Newcombe, now a widower with six children, decided to take the three eldest children back to England where, after settling them with relatives, he took a formal course in geology at the University of London.

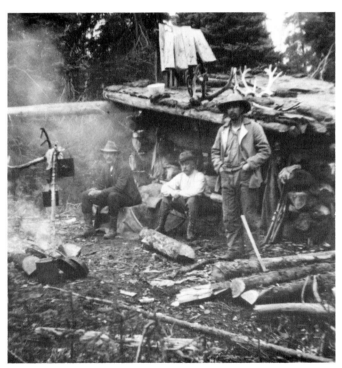

Life in the great outdoors, c 1890. A collecting trip in the Cascade Range, McKenzie Park, Bella Coola.

Like Fannin, N. H. Chittenden was commissioned to make a survey of land resources. Richard Maynard photographed Chittenden (left) with his crew in the Queen Charlotte Islands in 1884. A number of Indian artifacts and natural history specimens collected on this survey ended up in the Museum.

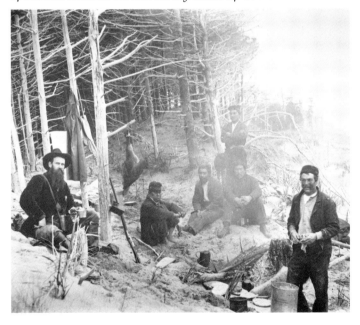

By the early 1890s, therefore, Dr. Newcombe had established an international reputation, both as a naturalist and as an anthropologist; and the Provincial Museum was gaining its own recognition as a reputable scientific institution.

The following year, 1892, leaving the three eldest children in England, he returned to Victoria and his three youngest children, to resume his practice. However, this time the practice apparently did not prosper and he became increasingly involved in his botanical and geological collections. After a brief and unsuccessful attempt to return to his first interest, alienism, he embarked on a new career. He became a collector on commission to George Dawson, of the Canadian Geological Survey, George Dorsey of the Field Columbian Museum in Chicago and Franz Boas of the American Museum of Natural History in New York.

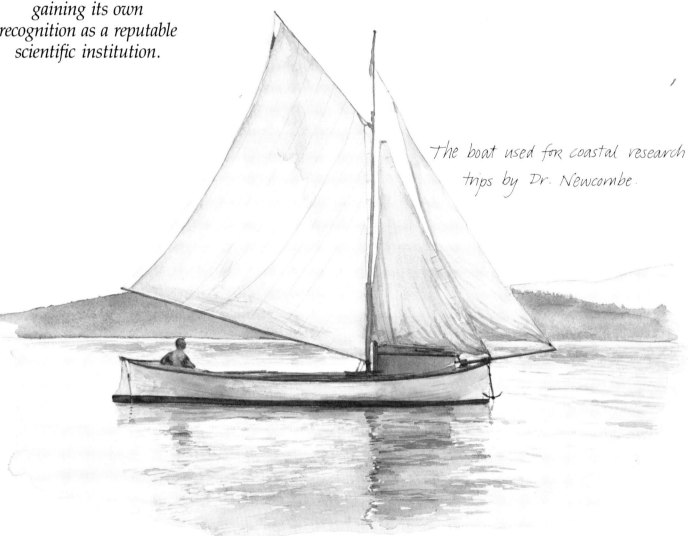

The boat used for coastal research trips by Dr. Newcombe.

The Grand Tour

By the early 1890s, therefore, Dr. Newcombe had established an international reputation, both as a naturalist and as an anthropologist; and the Provincial Museum was gaining its own recognition as a reputable scientific institution. By the turn of the century, Victoria was viewed by some with respect, by others with derision born of envy. It would not be an exaggeration to suggest that the intellectual life of the province centred itself there, and the spirit of scientific enquiry was focussed on the Museum and its auxiliary, the Natural History Society. So successful had Fannin's efforts been that, when the new Legislative Buildings, designed by Francis Rattenbury, were completed, the east wing was allocated to the Museum. In the spring of 1898, for the second time in a decade, Fannin moved his growing collections to more spacious quarters. Before this, though, he had received the following letter, dated June 11, 1896, from the Provincial Secretary:

The old Courthouse, 1895.

> I have the honour to inform you that the Government considers it desirable that you should proceed to London, England, via New York and visit the museums of Natural History in the cities mentioned, and also the Natural Museum at Washington, with a view to acquiring thereby such information as will prove advantageous to the proper conduct of the institution committed to your charge.
>
> It is thought that the practical acquaintance with the management, and arrangement of specimens, in vogue in old established museums which you will gain by your visit cannot but prove valuable to you when the time arrives for the removal of the Provincial Museum to the new premises in course of construction.

In *Science* (November 4, 1898) Harlan I. Smith, then Director of the American Museum of Natural History in New York, had complimentary things to say about the Provincial Museum:

> In proportion to the population British Columbia has an unusual number of natural history museums. These are exceptionally well administered, considering their isolation from other scientific institutions.
>
> The Provincial Museum at Victoria is by far the most important one Special attention is now being given to the building of groups of birds and mammals represented in their natural environments. The interest of the people in this work may be

... *from its beginnings, the Museum seemed to favour the idea of what is now called a diorama — an exhibit that attempts to display a specimen or artifact in its natural environment ...*

gauged from the fact that Mr. Fannin was sent to the great museums of England and the eastern United States to investigate the methods of preparing such groups.

The Museum is fairly well arranged, and the labeling will put to shame many of the great museums of the East

In fact, almost from its beginnings, the Museum seemed to favour the idea of what is now called a diorama — an exhibit that attempts to display a specimen or artifact in its natural environment, either life-size or as a scale model; whereas most museums still tended to display their specimens as single, mounted objects, often without any clear idea of groupings. In addition, of course, smaller specimens and objects would be displayed in glass cabinets, sometimes with a sense of grouping, sometimes, it appeared, almost at random. More than 90 years after Fannin promoted the use of dioramas, the Museum produced perhaps the ultimate in this genre — a full-scale re-creation of a forest environment.

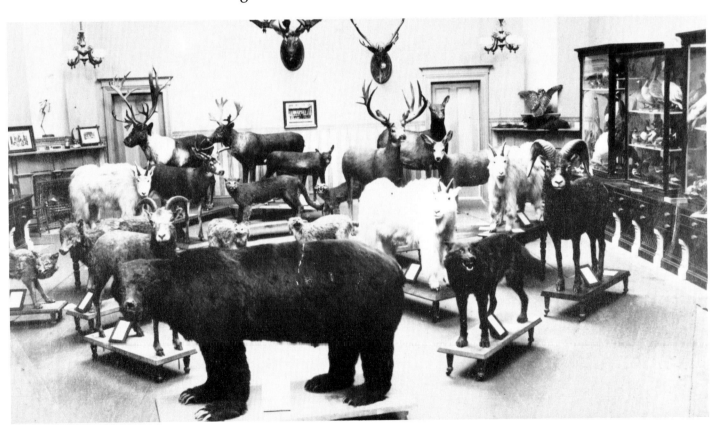

Taxidermy dominated the natural history displays through the 1890s.

While Harlan Smith's comments may smack of faint praise, in truth he had been drawn to the province because of the growing reputations of the scientists of the Natural History Society, and probably because he had been impressed by Fannin when visited by him in New York.

On his return, Fannin reported to the Provincial Secretary that his tour had been a great success and resumed his duties with a new vigour and enthusiasm. With a paid staff of one taxidermy assistant and two attendants, who acted as security guards and general factotums, he had brought the British Columbia Museum of Natural History a long way.

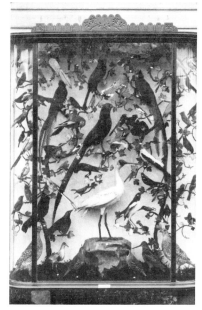

By the turn of the century the diorama, in which some of the animals' natural habitat was included, began to appear. This is one of the earliest of the Museum's dioramas.

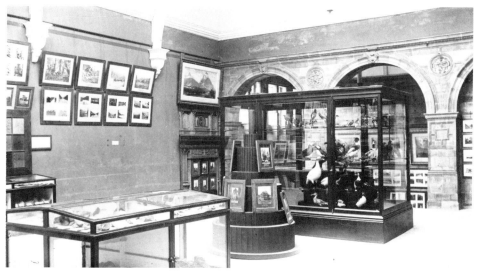

Mineral specimens, mounted birds and photographs on display in the old Courthouse, c 1895.

Clouds on the Horizon

here were, however, for the Museum and particularly for the Natural History Society, some clouds on the horizon — clouds that no one could have perceived at the time. In the same year that the Society came into being, Fannin hired a youth of 16 as an apprentice taxidermist who was to play a remarkably extended role in the history of the Museum, but not in the Natural History Society. By the turn of the century, too, plans were beginning to materialize for the foundation of a University in British Columbia. When the University of British Columbia came into being in 1911, it was in Vancouver, and perhaps an inevitable shift of focus for the intellectual life of the province took place. The Museum stayed in the east wing of the Legislative Buildings until 1968, only five years after the University of Victoria had been founded, when once more at least some of the intellectual and cultural hegemony it had enjoyed at the turn of the century returned to Victoria.

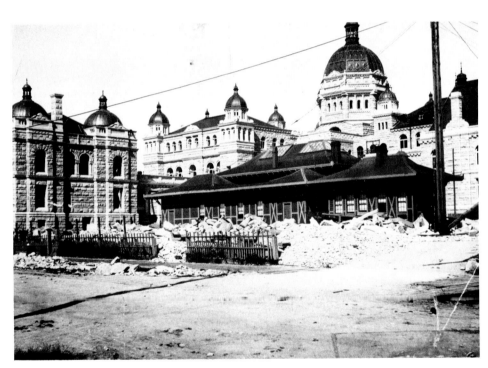

Designed by architect Francis Rattenbury, the new Legislative Buildings were nearly completed in 1897 (photographed from the west). The "Birdcage" in the foreground was demolished and replaced by the existing rose garden.

Consolidation

Consolidation

The Ending of an Era

By the beginning of the twentieth century, Dr. Newcombe's star was still very much on the ascendant. Jack Fannin's, unhappily, was sinking; his health had begun to deteriorate and, by the end of 1903, he was obliged to retire. The Natural History Society had high hopes that Newcombe would succeed Fannin as Curator of the Museum, for Newcombe's growing reputation as a biologist and anthropologist had already been acknowledged by the government. When Fannin had made his tour of museums in the United States and Britain in 1896, Newcombe had received the following letter from the Provincial Secretary:

> I have the honour to acquaint you that, during the absence of the Curator of the Provincial Museum from the Province you have been placed in charge of the said institution. In consideration of your services in this respect you will receive a salary of $50.00 monthly.

However, seven years had passed since then and presumably the Natural History Society must have had at least some misgivings about Newcombe's automatic appointment because they approved, at an Executive meeting held January 4, 1904, and forwarded to Premier McBride, a lengthy memorial listing Newcombe's qualifications to succeed Fannin as Curator:

> . . . we, the members of the Executive Committee . . . crave the liberty of strongly recommending to the Premier and the other members of the Government, the appointment of Dr. C. F. Newcombe as a successor to Mr. Fannin

> Dr. Newcombe is an ardent naturalist of various accomplishments as such: and in this capacity on the Pacific Coast, of which he has long been a resident, has won for himself recognition from a number of scientific societies on this continent and many learned men in Natural Science. We earnestly believe that under his supervision the Provincial Museum would obtain a much higher place than it has even at the present time; and that no other man in the Province is so eminently well qualified to carry on the work Mr. Fannin has so admirably begun

By the beginning of the twentieth century, Dr. Newcombe's star was still very much on the ascendant. Jack Fannin's, unhappily, was sinking . . .

43

An Unexpected Choice

Francis Kermode became Curator of the Museum in 1904, the year this photograph was taken.

\mathcal{T}here was a good deal more in the same vein. Yet, when the appointment was announced in February, 1904, the man named was one who had, until then, scarcely ever been mentioned in the records of the Museum or the Natural History Society: Francis Kermode. This must have come as a sharp disappointment to the members of the Society who, perhaps with some justification, regarded themselves as being in a better position than the government to judge the most appropriate person for the position. Unfortunately, no documentation seems to exist about the reasons for this decision, so one can only speculate. Perhaps the $50 a month he had received as Acting Curator in 1896 was no longer acceptable to the Doctor. Or perhaps the growing success of the Museum, and consequent anxiety about the increasing cost of supporting it, may have prompted the government to choose a junior contender who had no international reputation, and would therefore make no unreasonable salary demands. He could be relied on to do as he was told rather than promote an unacceptable growth rate in the Museum. At the moment, we have no way of telling. Perhaps in time, more documentation will be found to explain what seems an odd decision.

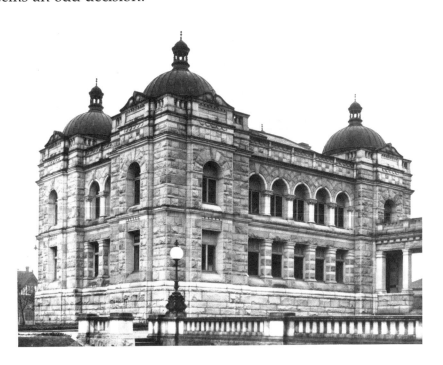

In 1898 the Museum moved to the premises it would occupy for the next 60 years: the East Wing of the newly completed Legislative Buildings.

The Clerk from ". . . a Mercantile Establishment . . ."

Francis Kermode was born in Liverpool, England, on June 26, 1874. His father, Edward, was a shipwright for many years in the Liverpool shipyards. Leaving his family in Liverpool, Edward came to British Columbia in 1881, moving shortly thereafter, for reasons which are not recorded, to China. In 1883, he returned to British Columbia and decided to settle in Victoria. He sent for his family, who arrived in November of that year. Francis was nine years old at the time and he completed his education — begun in "the parochial school of the Anglican church in Liverpool" — in Victoria's public schools. At 15 he left school to become a clerk in what was described only as "one of Victoria's mercantile establishments." Eighteen months later, in September of 1890, he was hired as an office boy and apprentice taxidermist under John Fannin at the Provincial Museum. From then until his appointment as Curator in 1904, there is no mention of him in any of the surviving documents.

Moreover, this dearth of documentation continues to plague us in trying to write about his career. There is so little material, in particular so little correspondence, one researcher has concluded that Kermode must have had a bonfire in the late 1930s, leaving in the files only those documents that show him in a favourable light. As a consequence, there is a tendency to regard him as a colourless figure who was a competent bureaucrat but by no means a distinguished scientist. Most of the surviving written material about Kermode suggests some respect for his abilities but none of the affection or admiration felt for his predecessor. Yet he presided over the Museum, first as Curator, later as Director, for 36 years — years during which the Museum grew slowly but steadily and did not succumb to the Great Depression of the 1930s.

There is so little material, in particular so little correspondence, one researcher has concluded that Kermode must have had a bonfire in the late 1930s, leaving in the files only those documents that show him in a favourable light.

The "Collectors" Depart

There was, nevertheless, one obvious change under his administration. The Natural History Society, at first gradually but with increasing certainty, ceased to be an auxiliary of the Provincial Museum. Whereas Fannin relied heavily on it for both collecting and interpretation, Kermode was clearly never much involved in the Society's affairs and determined to make the Museum, under his

The dioramas became more elaborate and imaginative.

stewardship, stand on its own. That its early promise to emerge as one of the more active and distinguished scientific institutes in the Pacific northwest faded may have been as much to do with circumstances, both intellectual and economic, as with any intransigeance on Kermode's part. It seems clear that he did not have the charisma, the presence as a speaker or as a writer, of either his predecessor or his successor, Clifford Carl. But he did have stamina and, much of the time evidently, the ear of the governments of his times.

". . . Business Takes Over"

There was a relatively brief revival of activity in the economic boom years between 1909 and 1913. The Museum had been created in response to public anxiety over the loss of so much ethnological material to museums in other parts of the world; yet, having created the Museum, the government showed little inclination to provide the funds necessary to make significant acquisitions. Kermode

The skill of the taxidermist was still predominant.

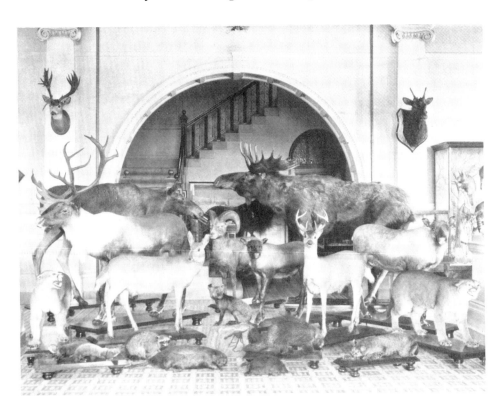

complained, albeit with no great vehemence, about this and, although C. F. Newcombe was asked in 1909 to rearrange the ethnology material according to tribe, instead of categories of use, no funds were provided for collecting. Nevertheless, Newcombe completed his task and produced an illustrated catalogue, *Guide to Anthropological Collection in the Provincial Museum*. There the spurt, if it can be called that, would have ended but for the intervention of E. O. S. Scholefield, the Provincial Librarian.

Douglas Cole (*Captured Heritage*, 1985) describes what happened:

> In his 1911 annual report, Scholefield cited the "high importance" of the matter as a justification to go beyond his departmental purview and urge "the desirability of acquiring a really representative collection of relics and tokens covering all phases of the Indian life of British Columbia. If the formation of such a collection is not undertaken at once, and vigorously prosecuted, it will be soon, very soon indeed, once and for all too late for the Province to acquire an exhibit worthy of the great ethnological field which it covers."

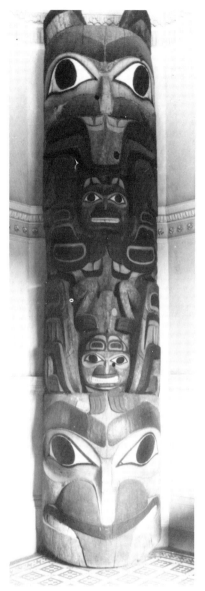

A Haida inside house post from the village of Skidegate, collected by Newcombe, stood in the entrance to the East Wing.

The province enjoyed a brief spell of affluence from 1909 to 1913. Dr. Newcombe was provided with $3,000 to collect ethnological artifacts. He doubled the existing collection.

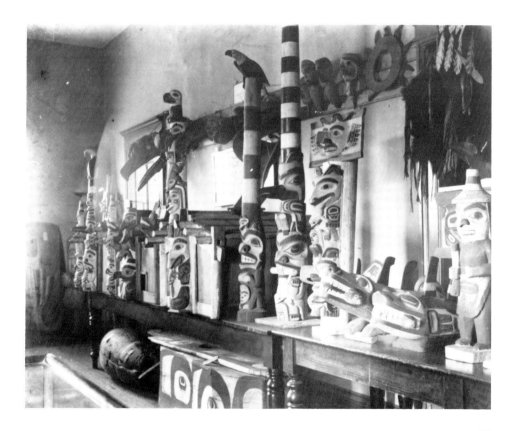

Three thousand dollars was a handsome appropriation for the times and Newcombe moved with his customary energy . . . doubling the Museum's ethnology collection from 1,390 to 2,837 items . . .

Fortunately, Scholefield had more clout with the minister than Kermode; and fortunately, the minister, Dr. Henry E. Young (whose other portfolio was Minister of Health) was at the time enthusiastically supporting museum and library activities. Douglas Cole continues his account:

> In April 1911 Scholefield and Young asked Newcombe "to take the field" and gather as representative a collection as was possible with the $3,000 placed at his disposal. The money came from Scholefield's "Collecting Archives" budget rather than from museum appropriations, Kermode being on the outs with his minister. (Even the next year, when the money was placed in the museum budget, Newcombe ignored Kermode, feeling "quite capable of getting necessary curios without his aid.")

$3,000-worth of "Strength and Significance"

Three thousand dollars was a handsome appropriation for the times and Newcombe moved with his customary energy and resourcefulness, doubling the Museum's ethnology collection from 1,390 to 2,837 items, providing "a solid basis which allowed the province to possess a collection, if certainly not of the first rank, yet of strength and significance."

The burst of enthusiasm for Indian art and artifacts in the province evaporated almost as quickly as it had emerged. In July of 1913, Newcombe observed dryly that "The Province is now impecunious, and so my engagements with the Museum are curtailed." And in 1914, Kermode wrote to advise the Provincial Secretary that "The Maintenance Vote for this year has been $5000 and Vote for Anthropology $2000. For the coming year I propose to cut out altogether the Vote for Anthropology, and to lessen the maintenance vote to $4000." Two years of economic decline, followed by World War I, gave the government the excuse it needed to practise severe austerity as far as cultural activities were concerned for many years to come.

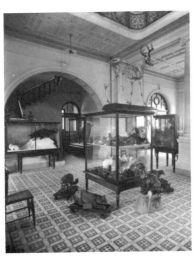

Elegant new quarters gave the Museum the luxury of ample space for a few years.

*H*owever, things had not ground to a halt. In 1910, Kermode was on the trail of a new species. The story began in 1878 when George Dawson, of the Geological Survey of Canada, reported on the work he had been doing in the Queen Charlotte Islands. In his report he observed that there was good evidence of wapiti (elk) on the north end of Graham Island. Then, in 1880, Alexander Mackenzie, a Hudson's Bay factor at Masset, sent out a fragment of the skull of a caribou with part of an antler attached, claiming it had been killed in the Virago Sound area. This find apparently persuaded Dawson that he had been wrong; that the signs he had seen were in fact not elk but caribou and, in 1900, he amended his report.

The specimen finally ended up in the Museum where, in 1900, Ernest Thompson Seton, the celebrated naturalist and author, examined it and decided it was a new species which he called *Rangifer dawsoni*. But most biologists were sceptical; they doubted the provenance because this, the only specimen, had been through too many hands; and because the habitat of mainland caribou had always been in relatively open and dry areas, whereas the Queen Charlottes were heavily timbered and distinctly humid. As a consequence, there followed several expeditions in the Virago Sound area, all searching for a live specimen. None was successful, yet nearly all claimed to have found what were unmistakably caribou tracks, together with dung and, on one occasion, caribou hair. Then, in 1905, a Captain Hunt, of the British army, brought out a shed antler. At the turn of the century, the word of a British army captain was evidently something that could not be ignored; consequently, a hunter and well-known amateur collector, Charles Sheldon, was asked by the United States Biological Survey, in Washington, D.C., to go to Graham Island in 1906 and see if he could resolve the matter.

Sheldon failed to find any live animals, but he, too, found the tracks, and dung. To complicate matters, the Indians in the area seemed to have no knowledge of caribou — but this, it was claimed, might be explained by the fact that the Indians had no need to go inland to hunt; they could find all the food they needed by the sea.

The specimen finally ended up in the Museum where, in 1900, Ernest Thompson Seton, the celebrated naturalist and author, examined it and decided it was a new species which he called Rangifer dawsoni.

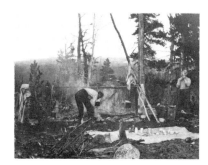

This turn-of-the-century photograph illustrates the change in living conditions when staff were in the field on collecting trips.

Catching Up with an Enigma

While biologists puzzled over this seeming enigma, Matthew Yoemans and Henry White, two loggers working in the area, finally caught up with four live caribou: two bulls, with antlers, a cow and a calf. The animals were far from timid, and the loggers shot all but the calf.

The skins and skulls were sent down to the Museum in Victoria, but the skins had been so poorly treated that Kermode, hoping to find more usable specimens to put on display, travelled up to the Charlottes in October, 1910, and tried to collect some himself. He, too, failed; thus Yoemans' and White's were the last living caribou seen on the Queen Charlotte Islands. The specimens in the Museum proved that the animals were considerably smaller than mainland caribou and varied in a number of other significant details; thus, they could not have been recently introduced as an experiment; the differences were significant enough to have required a considerable time span to evolve. They were clearly on the point of becoming extinct.

Matthew Yoemans and Henry White shot what were, as far as we know, three of the last four Dawson's caribou in the Queen Charlotte Islands. No further sightings of this species have been reported.

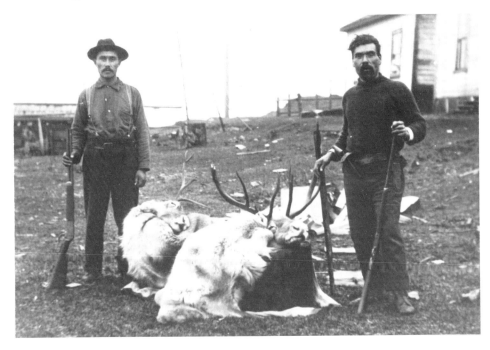

In 1972, Charles Guiguet, the Museum's Curator of Vertebrate Zoology, provided what seems the most credible explanation:

> Caribou probably got stranded on the Charlottes towards the end of the Vashon glaciation [the last ice age, approximately 12,000 years ago] which covered the entire coast. The animals probably re-invaded British Columbia along the coast where the ice (probably again) went [melted] first due to the marine influence (higher temperatures). The Q.C.I., part of the coastal complex, was joined to the mainland by land, and ice bridges over which the caribou crossed and got stranded when those bridges disappeared. Coastal climate is inhospitable caribou habitat. The mainland animals moved out of it into the interior as the ice went but the Q.C.I. animals could not do this. The individuals deteriorated due to the marginal range conditions, hence the dwarfed bodies, dwarfed, malformed and single antlers. These attributes are common to caribou on marginal range, e.g. southern B.C. and Idaho — we have several specimens that resemble those from the Q.C.I. And so the turn of the century saw them on their last legs — the introduction of deer is probably the last shaft, for isolated populations are most susceptible to the diseases and competition of non-isolates, e.g. smallpox and our natives, common cold and the Eskimo — on first contact was fatal.

There may yet be some answers if archaeologists find bones or other evidence of caribou in middens in the area.

Informing the Public

After the caribou incident, it becomes a question of piecing together such material as we have of the early years of Kermode's tenure as Curator, and we learn, mostly from brief newspaper articles and from *Annual Reports* of the Museum, first published in 1913, what was going on in the Museum.

By 1910, there were four members on staff:

Francis Kermode	Curator
Ernest M. Anderson	Assistant Curator
Walter Behnsen	Second Assistant
Samuel Whittaker	Janitor and Attendant.

There is no record of when E. M. Anderson joined the staff, but we discover from later correspondence that he may have been hired, probably in a part-time capacity, by Fannin. Of Walter Behnsen we know nothing. The annual salary for staff amounted to $4,056; another $1,500 was provided for miscellaneous expenses and travel.

(Right to left) Francis Kermode, William Carter, Assistant Biologist, and an unidentified companion.

One of the original objectives of the Museum had been "to inform the public," and publications had begun to appear under Fannin's name as early as 1891, with his *Check List of British Columbia Birds.* This was followed by *A Preliminary List of the Mammals of British Columbia,* in the Bulletin of the Natural History Society, 1893; C. F. Newcombe's *Preliminary Check List of Marine Shells of British Columbia,* 1893; Fannin's *Preliminary Catalogue of the Collections of the Natural History and Ethnology in the Provincial Museum,* 1898; F. Kermode's *Catalogue of British Columbia Birds,* 1904; E. M. Anderson's *Catalogue of British Columbia Lepidoptera,* 1904; C. F. Newcombe's *Guide to the Anthropological Collection in the Provincial Museum,* 1909; and the anonymous *Visitors' Guide to the Natural History and Ethnological Collections in the Provincial Museum,* 1909.

Another Grand Tour

From the newspapers we know that, in 1912, the Museum enjoyed a facelift.

> For the past few days the provincial museum has been in the hands of the painters and kalsominers [plasterers], and now that that part of the scheme of improvements conceived on its behalf has been executed, or nearly so, the curator, Mr. Kermode and his assistants are busily rearranging the stock of exhibits, and at the same time enlarging it by bringing up from the provincial vaults a number of exclusive specimens . . . [which] will be so arranged as to afford the best possible educative and informative value to the inspecting public.

A month after this renovation, Francis Kermode was on his way for an extensive tour of museums in the United States, Britain and Europe. It was something of a grand tour. He visited the Field Museum in Chicago, the newly completed National Museum in Ottawa and the Smithsonian Institution in Washington, D.C. From there he went to New York to attend the annual convention of the American Association of Museums, most of the sessions of which were held in the New York Museum of Natural History. While in New York, he also visited the Brooklyn Museum of Arts and Sciences, the New York Zoological Park and the Metropolitan Museum of Arts. Next, he sailed for England on the *Oceanic* to visit the three branches of the British Museum. Finally he crossed the Channel to France and Paris, where he visited the Jardin des Plantes which, in spite of its name, was actually a zoo. From Paris he travelled to Strasburg, Frankfurt, Hamburg and Berlin.

Finally he crossed the Channel to France and Paris, where he visited the Jardin des Plantes which, in spite of its name, was actually a zoo.

"Returning to England," as the *Victoria Colonist* reported, "via Cologne and Flushing, Mr. Kermode spent the remainder of his time before embarking on the *Empress of Ireland* visiting Liverpool and Edinburgh, in which latter city he inspected the well-managed museum, which shares with the British Museum the honours and emoluments of being a state institution."

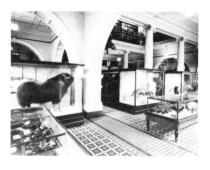

Growing collections did not hide the beauty of the East Wing's interior.

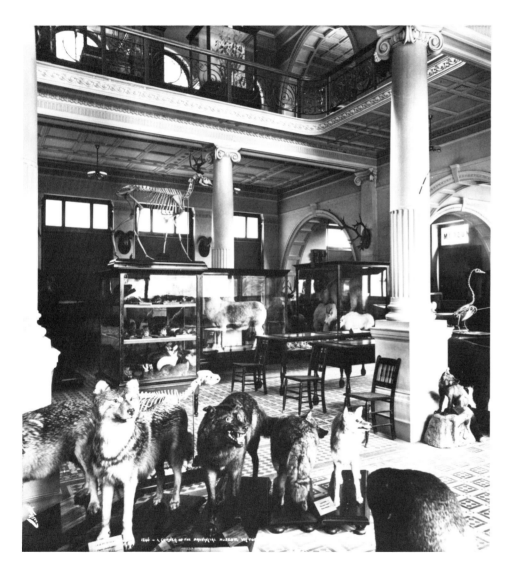

Hornaday became increasingly enthusiastic. The discovery of a new species, particularly something as striking as a white bear, would undoubtedly draw visitors — both scientific and otherwise — to his zoo.

The Polar Bear that Never Was

*H*owever, the most significant episode in Francis Kermode's career had its beginnings as early as 1900. In November of that year, a fur trader in New York, J. Boskowitz, received a shipment of skins from the west coast. Among them was a small, cream-white bear skin. Realizing that it was not a polar bear, and so at least something of a rarity, he got in touch with Dr. William Hornaday of the New York Zoological Society.

Dr. Hornaday, who seems to qualify for the description of a scientific entrepreneur, promptly set off to discover more about what promised to be a new species for his zoo. He learned that this particular skin had been sold to a trading post by an Indian living in the Nass River country — to Hornaday an exceedingly remote area in northwestern British Columbia. He concluded that the skin could not have belonged to a young polar bear because some 2,300 miles (3 700 k) separated the southernmost habitat of the polar bear from the Nass River basin.

Harold A. Yokum, Curator of Natural History at the Kansas City Museum wrote that, "Hornaday enlisted the interest of Francis Kermode, then Curator of the Provincial Museum, Victoria." But Kermode did not become Curator until 1904; so it was probably Fannin he first contacted. In any event, Hornaday learned from Victoria the name of a fur dealer in Port Essington, British Columbia, who might have sold the skin. The dealer, Robert Cunningham, wrote to say that almost every season he traded for white bear skins from the Indians, and that these skins always seemed to come ". . . from the district south of the Skeena River, sometimes as far south as Rivers Inlet. Most come from the Kitimat Arm of Douglas Channel, which is on the north side of Hawkesbury and Gribbel Island."

Hornaday became increasingly enthusiastic. The discovery of a new species, particularly something as striking as a white bear, would undoubtedly draw visitors — both scientific and otherwise — to his zoo. Even at this early stage, though, there were sceptics who suggested the bears were simply albino black bears. Hornaday, and later his supporter, Kermode, would have none of it and they pressed on with their search for a specimen. However, it wasn't until 1904 that the Provincial Museum finally got its first dead specimens: two young cubs, a male and a female, from Princess

54

Royal Island, and an adult male from Gribbel Island. Hornaday, whom one suspects was after a live specimen for his zoo, promptly named it *Ursus Kermodei.*

In the 1905 *Ninth Annual Report of the New York Zoological Society,* under the heading, *A New White Bear from British Columbia,* Hornaday said, "There is not the slightest probability that albinism is rampant among any of the species of bears of North America, and it is safe to assume that these specimens do not owe their color to a continuous series of freaks of nature." But the controversy about *Ursus Kermodei* really heated up in 1924 when, for the first time, a live cub was captured by an Indian at Butedale. The Indian sold the cub to a white man, Flowers, which at the time was against the law, and Flowers promptly rushed it down to Vancouver with the

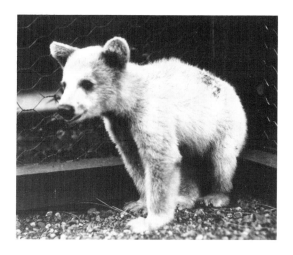

The white bear cub that Dr. William Hornaday of the New York Zoological Society coveted so ardently. Hornaday declared it a new species and named it Ursus kermodei, *hoping by doing so to spur Kermode to find him a live specimen for his zoo. Instead, when Kermode finally obtained a live specimen in 1924, he kept the bear in a cramped cage in Victoria's Beacon Hill Park. There it spent 24 lonely years before dying of old age in 1948.*

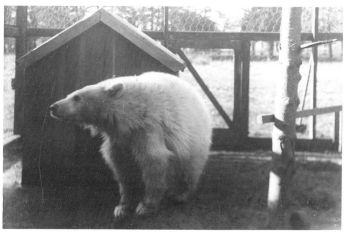

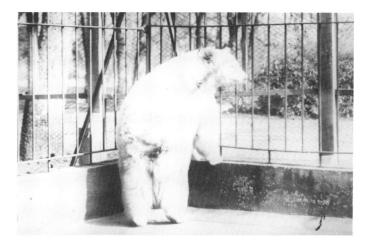

intention of slipping across the border and selling the unfortunate animal in the United States. However, the Provincial Game Conservation Board got wind of this and, armed with a magistrate's warrant, took custody of it. The cub ended up in Kermode's charge, in a small pen in Beacon Hill Park, where its cramped and inadequate quarters roused something of a storm among local animal lovers. Kermode, claiming he had no funds to improve the situation, passed the matter over to the City Parks Board. They made some minor improvements and the bear, a female, lived out its lonely and restricted life, dying of old age in 1948.

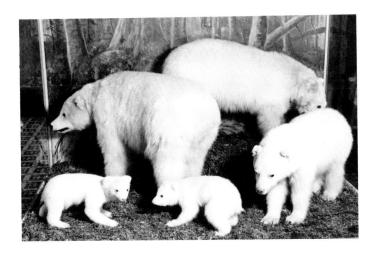

A grouping of white bears displayed in the Museum. By 1928, biologists had concluded that the white bear was simply a colour phase of the familiar black bear, and Hornaday quickly lost interest in his "new species."

Not Even an Albino

*I*n the meantime, Hornaday had been busy trying to acquire the bear for his zoo. In a letter to Kermode, dated September 4, 1924, he wrote at length of the advantages that would accrue to both Kermode and himself:

> Needless to say, we are exceedingly anxious to procure it. The specific status of your bear has been openly flouted here in the East, and the American Museum of Natural History has the temerity to show a group of "Color Phases of the Black Bear" in which there appears *Ursus Kermodei.* This discredits both the bear and me, and I have a horrible fear that the flouting of both of us has been done with some malice aforethought.

> Now for heaven's sake, help us to get a permit for the exportation of this Kermode bear and have the animal shipped to us If we don't get that cub I will perish of disappointment. If we get it, you

56

and I and the bear can crow over our detractors. Remember that I am fighting your battle for the supremecy of this species that has been named in your honor!

Of course the people of Victoria will be interested in keeping the bear in that city, but let me point out to you the fact that here it will be seen by 2,500,000 people each year; that a great fuss will be made about it in the newspapers, and the animal, its species, and British Columbia as a whole, will get a great amount of free advertizing

These are hardly the words of an objective scientist. Kermode, perhaps happy to keep the bear himself, wrote a soothing letter, regretting that he could do nothing with the Game Conservation Board.

Hornaday was right in claiming the bear was not an albino, but later studies support the American Museum of Natural History in their contention that it was a colour phase of the *Ursus (Euarctos) americanus* group — the others being black, cinnamon, brown and blue. This was established as early as 1928 by Dr. E. Raymond Hall, at the University of California, after he had examined the skulls of five white bears from Gribbel and Princess Royal Islands. Hornaday neither got his white bear nor perished from disappointment, but he did lose interest once the glamour of a new species began to fade.

Hornaday neither got his white bear nor perished from disappointment, but he did lose interest once the glamour of a new species began to fade.

Some Firsts — Objectives, Reports and New Realities

Meanwhile, going back a few years to 1913, we learn that the first "Act respecting the Provincial Museum of Natural History and Anthropology" was promulgated on February 21. The Act established the following "Objects" for the Museum:

4. (a.) To secure and preserve specimens illustrating the natural history of the Province:
 (b.) To collect anthropological material relating to the aboriginal races of the Province:
 (c.) To obtain information respecting the natural sciences relating particularly to the natural history of the Province, and to increase and diffuse knowledge regarding the same.

Such a long interim — 1886 to 1913 — before the first Legislative sanction of the Museum seems odd, but no one at the time remarked on it. Now, the words "securing" and "collecting" were finally an official part of the Museum's mandate; and Kermode was no longer a Curator but a Director. There is, as well, no mention

whatsoever of the Natural History Society as an auxiliary to the Museum. Kermode was firmly in the saddle and would remain so for another 27 years.

We learn, too, from the first *Annual Report of the Museum, 1913*, published in 1914, that Anderson had been engaged on several field trips to the Okanagan Valley, where he collected 306 birds, 580 birds eggs (comprising 114 sets of eggs with nests), 278 mammals, 36 batrachians and reptiles, 11 fishes, and over 4,000 entomological specimens. Kermode made several weekend trips to Bare and Saturna Islands, and reported he was attempting to have Bare Island declared a bird sanctuary. Newcombe continued his work of collecting anthropological material relating to the Coast tribes and, because the commercial fishermen were engaged in one of their periodical campaigns to have all sea-lions destroyed (on the grounds that they were depleting salmon stocks), he was commissioned by the Fisheries Department to undertake a study of their habits and life history. Kermode joined Newcombe on one of his trips to islands off Cape Calvert. He reported that their launch *Chaos* passed *Karlack*, the vessel heading north with the Arctic Expedition (an extensive scientific exploration, sponsored by the Dominion government and led by Vilhjalmur Stefansson), in Fitzhugh Sound. In September, Kermode, accompanied by his assistant, presumably Anderson, left for a general zoological collecting trip in the Atlin area. He complained that one month was insufficient for his purposes and he hoped to spend a full season there the following year.

This hope does not appear to have materialized and, by the end of 1914, we see the beginnings of wartime retrenchment. In a memorandum to the Provincial Secretary, H. E. Young, Kermode wrote, as mentioned previously, that he was going to eliminate the $2,000 Anthropology vote and reduce the maintenance vote by $1,000.

It is safe to assume that these reductions were not purely voluntary. They had been heavily prompted by the government and they dealt a long-term blow to the anthropological collections which, for several years after that, had to rely on donations, many from Dr. Newcombe.

Hail to the Chief!

The most significant event in 1915 seems to have been a visit by former President of the United States, Theodore Roosevelt. He was photographed on the steps of the Museum with Premier McBride, Francis Kermode peering shyly over his shoulder.

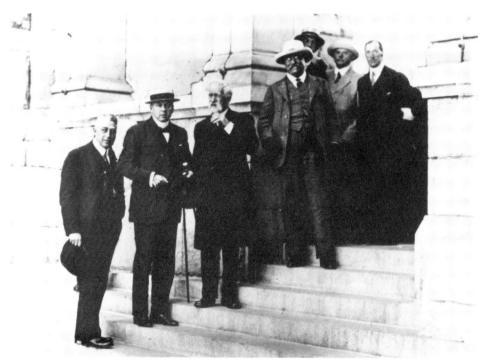

Francis Kermode peers shyly over the shoulder of his distinguished visitor, Theodore Roosevelt, former President of the United States, on the steps of the Legislature in 1915. (Left to right) John Cochrane, Sir Richard McBride (Premier), A. H. Freeman, Roosevelt, Kermode, Hon. D. M. Ebertz, unidentified.

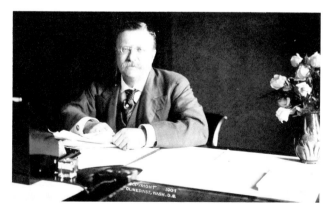

Teddy Roosevelt, sometimes known as the cowboy president, was an early and very effective conservationist.

The Dominion government, responding to claims from the west coast canneries (unsupported by any objective evidence) that sea-lions were decimating salmon stocks had put a bounty on sea-lion lips; the provincial government supplemented it with another $2.00 per lip.

\mathcal{I}n 1916, the sea-lion controversy began to heat up. Dr. Newcombe's preliminary report, published in 1915, was cautious and failed to throw much light on whether or not sea-lions posed a serious threat to salmon stocks; but it did pinpoint the fact that there were three major rookeries on the west coast. The Dominion government, responding to claims from the west coast canneries (unsupported by any objective evidence) that sea-lions were decimating salmon stocks had put a bounty on sea-lion lips; the provincial government supplemented it with another $2.00 per lip. Although it was recorded that one fisherman had claimed this bounty on no less than 1187 dead sea-lions in one year, the effect on the overall population was not perceivable. So, more vigorous steps were proposed.

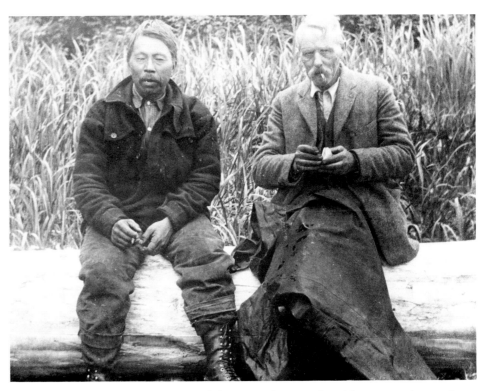

Dr. Charles Frederick Newcombe (right) pausing for a smoke with a companion on the Queen Charlotte Islands.

An article in Vancouver's *Daily News Advertiser* (September 10, 1915) suggested the worst to the conservationists.

Asphyxiating gases for the sea-lions; machine gun batteries for the entrenchments of the salmon killers; high explosive mines for all fortified places occupied by the canneryman's merciless enemies. These are some of the methods of "frightfulness" proposed to the Government commission appointed to launch an aggressive campaign against sea-lions which are proving [sic] so destructive to British Columbia's fish supply

. . . there are three well defined rookeries Here the sea-lion congregate for breeding purposes and are found in great numbers, the latest estimate being eleven thousand

To exterminate the amphibians by the use of fishermen's rifles seems a hopeless task, but by subjecting the rookeries to a bombardment from machine guns mounted on scows or vessels of the fisheries department, the planting of mines among the rocks where the animals make their habitat or even by releasing poisonous gases from scientiflcally constructed bombs, it is believed the rookeries can be depleted and adjacent waters freed from their depredations.

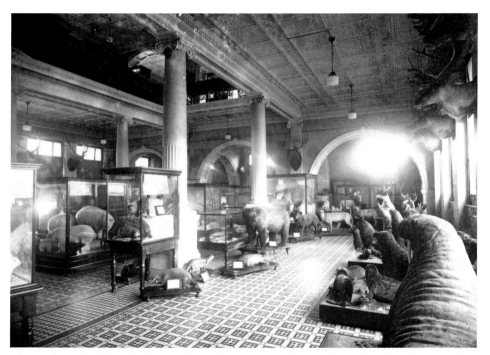

Kermode's white bears join Fannin's walrus among the growing collection of mounted specimens.

This gallery was devoted to ornithology, paleontology and invertebrates. As the number of visitors grew, exhibits had to be displayed behind glass for protection.

So far as it is known the sea-lion is of no value, commercially or otherwise, and to protect the species serves no purpose as far as I am aware . . .

Fortunately, this plan was being held in abeyance until the return of Dr. Newcombe and the publication of his final report. In the meantime, Kermode had written in April of 1915 to W. J. Bowser, Acting Premier, to ask that both the federal and provincial bounties on sea-lions be abolished until more was known about their feeding habits. As a consequence of this and vigorous representations by such distinguished naturalists as P. A. Tavernor and J. M. Macoun, the bounties were temporarily suspended. Kermode was quick to claim credit and some of his contemporaries were waspish about this. "Apparently one may have any assertion believed," wrote Dr. McLean Fraser, Curator of the government biological station in Nanaimo, and a member of the Commission, "if one only shouts loudly, if one is to judge by our friend Kermode's experience on the sea-lion question, since his claim has been calmly acknowledged by Mr. Clyde Patch in the Geological Survey report for 1916, just to hand. Of course we know, that our Friend as well as another Provincial official finds it necessary to claim the credit for everything done on the Pacific coast to try to insure retention in office but why a Dominion official should acquiesce in the imposture is rather beyond understanding".

However, these efforts by the early conservationists had little effect. The slaughter of sea-lions continued for many decades. In 1937, a Mr. J. A. Motherwell, signing for the Chief Supervisor of Fisheries, gave the following figures for sea-lions destroyed annually by machine guns mounted on the CGS *Givenchy:*

1931-32	-	1357	1934-35	-	786
1932-33	-	1123	1935-36	-	623
1933-34	-	923	1936-37	-	2679

The "Final" Solution

But a member of the Fisheries Advisory Board, reflected the final word on Ottawa's attitude to conservation. D. N. McIntyre did not mince words:

> In reply I beg to state that I have little or no sympathy with the protest The ravages made by the sea-lions upon fish of various kinds is undoubted. So far as it is known the sea-lion is of no value, commercially or otherwise, and to protect the species serves no purpose as far as I am aware

[Mr. Kermode] has expressed the fear that the sea-lion, like the buffalo, would disappear from the list of fauna of Canada. As it was necessary for the buffalo to be obliterated before the vast area of the prairies were available for cattle grazing and farming with the advent of the White settler, so the sea-lion must go with increased fishing on [the West] coast. I have no more sympathy with pleas for its preservation in any place else than a museum or an enclosed reserve of some nature, than I have with the protests of the sentimentalists who deplore the destruction of the buffalo. They stood in the way of the progress of civilization and they had to go. Peace to their ashes!

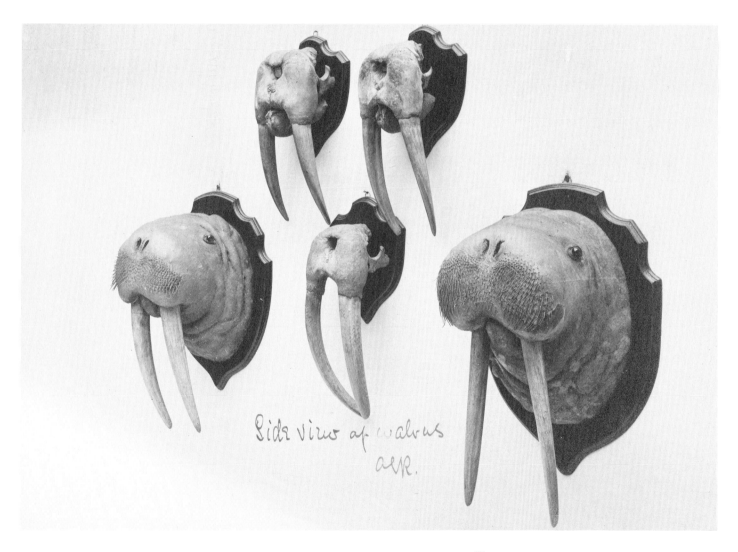

As if One Battle Wasn't Enough

*I*n 1916, too, another battle was being waged. Kermode was falling out with his assistant, Anderson. In a memorandum to Dr. McGuire, the Provincial Secretary, he complains of Anderson's behaviour during a field trip. (Although other sources claim that field trips were suspended during the First-World-War years, clearly some were still undertaken.)

> Sir:
>
> For your information I may state that this year I sent Mr. E. M. Anderson up to the Seton Lake Hatchery to collect in that district. I advanced him the amount of $100.00 in two sums of $50.00, to pay his expenses, and he was to turn in to me receipts for expenditures, so as to keep him $100.00 in advance while he was away. On 27th June I wrote him asking for further information regarding his expense account Instead of writing to me and giving me the information required, it appears that on July 4th he took it upon himself to pack up all his material and outfit and left the Hatchery and came down here without authority and in a beastly drunken condition and came up to my office and attacked me in a most disgraceful manner in the presence of a visitor In fact he was in such a beastly condition that he was heard all over the Museum by my staff.

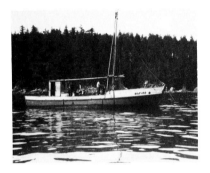

Summer field trips along the coast provided some compensation for low salaries.

Apparently things were patched up the following day and Anderson returned to Lillooet to complete his season of collecting. But on October 3 he received a terse memo from the Provincial Secretary advising him that he could no longer consider himself in the employ of the government. There was an interesting postcript to this dismissal. In 1918, Anderson wrote to the Chief of the Bureau of Entomology, Department of Agriculture, in Washington. D.C., advising him that he, Anderson, had shipped him some boxes of insect specimens from British Columbia, expressing the hope that he would be reimbursed for them. The letter, which had a Victoria address, was marked: "On Active Service with the Canadian Expeditionary Force", and spoke of "severing my connections from the Prov. Museum of Victoria (after 20 years service)"; thus, if this is true, Anderson must have been hired by Fannin shortly before the Museum moved to the East Wing of the Legislative Buildings.

In 1921, a curator of entomology at the Smithsonian wrote to advise E. H. Blackmore (Anderson's successor, who had been hired in 1918) that "several boxes of British Columbia insects bearing the name of E. M. Anderson" had been found in a storeroom. Did they

belong to the Museum? Blackmore's response was that "The material you speak of belongs to the Provincial Museum of Natural History Mr. Anderson was discharged for misconduct in 1916 Anderson got away with a lot of material as well as equipment and it was supposed that the insects you speak of were amongst them." The specimens finally found their way back to Victoria.

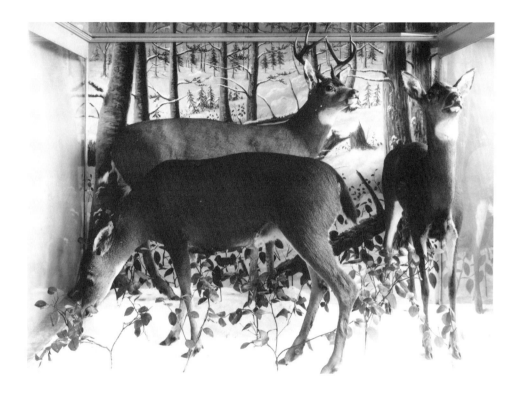

Judging by the Annual Report, 1919 was a low point in the Museum's history.

State of the art display techniques in the 1920s.

The Shoes Begin to Pinch

𝒥udging by the *Annual Report*, 1919 was a low point in the Museum's history. Strapped for material, Kermode spent two-thirds of the report reviewing the history of the Museum while hinting strongly that a new and larger building, together with increased staff, should be thought about now that the war was over. Under the heading, "Activities," Kermode wrote:

> As will be seen by the report in the several branches of natural history, no actual field parties were sent afield during the last

summer, but this does not mean that the activities of the Museum were dormant, as considerable work has always to be done in connection with the Museum, in classification and identification of specimens from time to time, to make them more accessible to inspection and for study.

This work is carried on by a very small staff, all scientific work involving upon [sic] the Director and Assistant Biologist, who are assisted by a few personal friends. The invaluable assistance afforded the institution by members of the large institutions of America, more particularly the staff of the Smithsonian Institution and the Biological Survey of the United States National Museum of Washington, D.C. (to whom a large number of specimens are sent for their specialists to identify and verify), cannot be too highly appreciated.

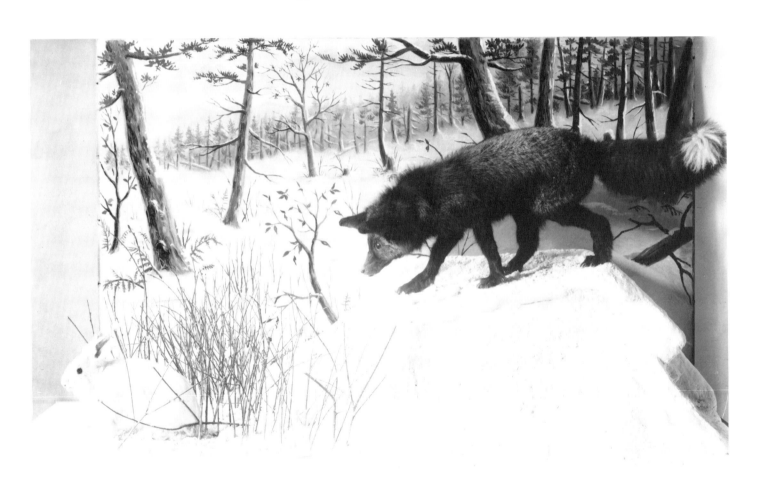

Kermode was never forceful in his demands for additional staff, and these hints of dependence on others, instead of developing expertise in the Museum's staff, do not seem to have moved the politicians of the time. Many years were to pass before the staff began to increase, and before university-trained specialists were hired.

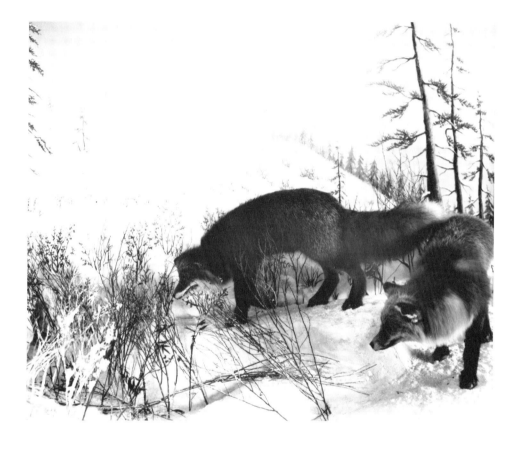

. . . by 1921, something had to be done about the space problem The solution was to excavate a basement in the East Wing and turn it into exhibition space.

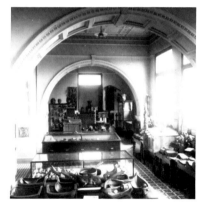

Display space began to dwindle as collections grew.

Stretching the Shoe

However, by 1921, something had to be done about the space problem. Naturalists, anthropologists and government servants in the field had been donating a significant quantity of artifacts and specimens and space was simply running out. The solution was to excavate a basement in the East Wing and turn it into exhibition space. This made it possible to bring out a significant number of anthropological artifacts to put on display.

. . . a number of leading Anthropologists of eastern North America who were greatly pleased with the display of this valuable material, it being the best local collection in America showing the primitive life of the aboriginal races of this Province . . .

Although, relatively speaking, the 1920s were boom times, none of the affluence reached the Provincial Museum. In a long, rather confusing memo to J. L. White, Deputy Provincial Secretary, in 1922, Kermode pleaded for extra help now that the recently excavated basement had provided four additional anthropology exhibit rooms to the Museum. He wanted two extra attendant/janitors. There is no record that such extravagance was approved. The two incumbent attendant/janitors had to clean the Museum between eight and nine in the morning, Monday to Saturday; then work as attendants (security guards) until five p.m., when the Museum closed for the day.

Some six months before the publication of the formal *Annual Report*, the custom in those days was for the Minister to call for what he termed "a succinct report on the activities of your branch or department during the past year," outlining changes, progress, plans for the coming year and, "where it excels similar departments in other Provinces."

The Only One of its Kind West of Toronto

Kermode's report for 1922, dated October 16, would hardly be considered succinct by present standards; under the heading of *Progress*, he reported that:

> The collection has been greatly admired by many visitors and others who are interested in the Indian tribes of British Columbia. The installation has been made according to the linguistic tribes, Kwakiutl including Nootkan; coast and Interior Salishan, Haida, Tsimshinn [sic], Athapaskan or Dene, Kootenaiain. Several large totem poles have also been installed in the entrance hall and the entrance to the basement. This collection has been inspected by a number of leading Anthropologists of eastern North America who were greatly pleased with the display of this valuable material, it being the best local collection in America showing the primitive life of the aboriginal races of this Province, and said to be so by Dr. Franz Boas, Anthropologist, Columbia University, U.S.A.; Lieut. Col. G. T. Emmons, R.N., U.S.A.; George Heye, Director, Museum [of the] American Indian, Heye Foundation, New York; Harlan I. Smith, Archaeologist, Victoria Memorial Museum, Ottawa; Dr. Leonhard Stejneger, Smithsonian Institution, United States National Museum, Washington, D.C.; and Dr. Goddard, from the American Museum of Natural History, New York, U.S.A. These gentlemen all visited the collection this summer and spent a considerable time in the Museum during their stay in this city

The number of visitors to the Museum for the last nine months, since the publication of the Annual Report for 1921 has been approximately 18,995. This does not include Mr. and Mrs. and very often several members of a family; teachers and their classes whose attendance has increased materially, neither does it include Asiatics and other foreigners

The Provincial Museum is recognized by scientists as one of the leading educational institutions of the West and is the only one of its kind west of Toronto.

More Realities and a Touch of Restraint

Considering he had a staff of only five people, and the budget for 1922, excluding salaries, was only $2,695.00, Kermode can surely be excused if there is a tinge of bragging about the last paragraph. A more cogent example of just how small the operation was in those days is provided by a memo from Kermode to the Deputy Provincial Secretary, dated March 6, 1924:

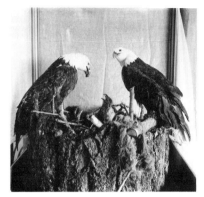

Thirty years after this photograph was taken, the Museum opened a natural history gallery composed entirely of life-sized dioramas.

With a view to reorganizing the staff of the Provincial Museum, made necessary by the resignation of Mr. W. R. Carter [who had been the Assistant in Biology], I beg to submit the following suggestions:-

1. That an extra stenographer be appointed to the office of the museum to do the general office work, thereby allowing Miss Redfern to attend to the botanical part of the work, formerly done by Mr. W. R. Carter. There is sufficient money for this purpose in the vote for the fiscal year 1924-25.

2. The man who is to take Mr. Carter's place is a skilled Lepidopterist [butterflies and moths] and Coleopterist [beetles and weavils], and it would be possible to do away with the services of Mr. E. H. Blackmore of the Dominion Post Office staff, who at present receives the sum of $25.00 a month for doing this work, and this would be put towards the salary for the extra stenographer. [Blackmore had been hired as Kermode's assistant in 1918. Presumably he had left to join the Post Office and was now moonlighting.]

3. All temporary maintenance during the year would be eliminated, as it would be arranged for the staff to double up on the work during holidays and any absence for illness which might occur.

4. It would be possible, with these changes, to have two of the staff always on the main floors of the museum, which is very desirable, as it is not fair or just to any of the staff to have the responsibility of attending to three floors alone during the hours the

69

It was slow, plodding but nonetheless valuable work that Kermode and his tiny staff were accomplishing, and attendance figures (up to 57,000 in 1928) seem to suggest a significant measure of public interest.

museum is open to the public. It has been reported to you more than once that articles have been stolen, and the present arrangement of one man on the floors on Saturdays and Sundays could be avoided, thereby lessoning the chances of losing any more valuable material. It would also make it more convenient for the general public, who are always asking for information regarding the exhibits.

Once again, we do not know if Kermode's very modest proposal was accepted; but in a brief report to the Minister in 1924, Kermode records that

> . . . a room on the main floor which had been an office for some time was converted into the Provincial Herbarium. This necessitated new cabinets being made and it was not until the early part of 1924 that the work of installing the specimens was begun. Over two hundred specimens of plants were collected, mounted and labelled during the year; these were added to the Herbarium which now contains over 6,000 specimens, representing the flora of the greater portion of British Columbia. Mr. W. R. Carter the Assistant Biologist resigned his position at the end of January, and as no new appointment was made until April 1st, the work of completing the new Herbarium was delayed to some extent.

It was slow, plodding but nonetheless valuable work that Kermode and his tiny staff were accomplishing, and attendance figures (up to 57,000 in 1928) seem to suggest a significant measure of public interest.

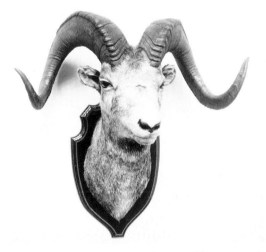

The traditional mounted head was still very much in evidence.

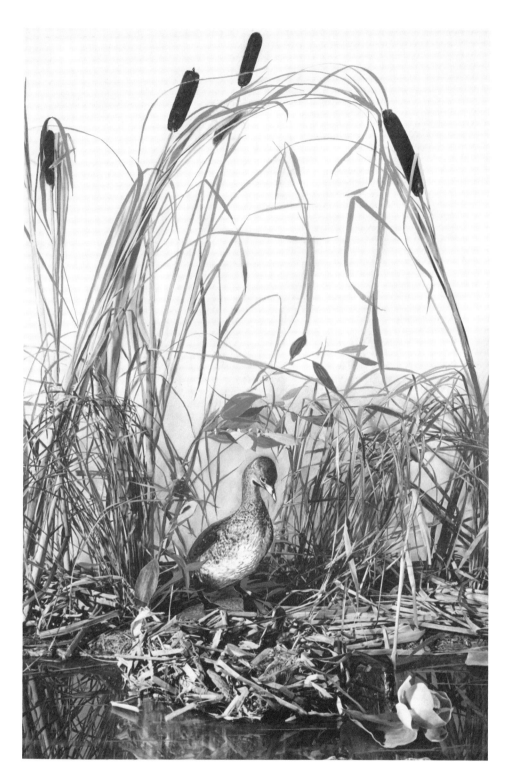

A pie-billed grebe moves onto its nest.

71

On the Occurrence of the Plumed Egret

In a letter from Brooks to Dr. Joseph Grinnell of Berkeley, written in 1917 and quoted in Hamilton Mack Laing's Allan Brooks: Artist, Naturalist, *Brooks said, "To keep Francis Kermode in Victoria is almost a crime."*

*M*eanwhile, there had been some academic skirmishing to enliven Kermode's life. In the April, 1923, edition of the *Canadian Field-Naturalist,* he published one of his infrequent scientific papers: *Notes on the Occurrence of the Plumed Egret (Mesophoyx intermedia) in British Columbia.* The specimen in question, an Asiatic bird not previously reported in North America, dated all the way back to Jack Fannin's private collection. It was recorded as being shot by an Indian at Burrard Inlet in May, 1879, who gave it to Captain Oliver G. Harbell, a friend of Fannin's who, in turn, promptly took it to Fannin. Fannin mounted the specimen and donated it to the Museum with the rest of his collection when he became Curator in 1886.

Kermode had sent the specimen to The Biological Survey Department in Washington, D.C., for a positive identification and took some pains in his article to verify that it was the bird Fannin had collected and not one substituted at a later date. He even included a formal deposition from Captain Harbell to that effect. However, the distinguished ornithologist, Allan Brooks, responded in the September, 1923, issue of *The Condor* with a somewhat aggressive rebuttal entitled *A Comment on the Alleged Occurrence of Mesophoyx intermedia in North America.* "Before accepting this extraordinary addition to the North American list" said Brooks, "it will be as well that all the facts bearing on the case are presented, and I regret that Mr. Kermode has not submitted these himself." Brooks went on to claim that a commercial outlet in Victoria had been selling skins of the Japanese Egret in full nuptial plumes when he visited Victoria in 1891.

> What probably happened was this: Mr. Fannin, then gathering the excellent series of mounted British Columbian birds for the newly established Provincial Museum, had taken one of these Japanese egrets to represent the Snowy Egret, assuming it to be the same species which he had had in his collection in 1879, taken at Burrard Inlet. That he had at that time one of the two species of American egret, or an albino of some other heron, I do not attempt to deny; but knowing his delightfully inconsequent methods as I did, I do not think he would have regarded this substitution as at all un ethical. I could quote somewhat similar actions, together with extraordinary lapses of memory on the part of my old friend in the matter of ornithological records, were it worth while; and Mr. Kermode has told me many amusing anecdotes of this nature in the same connection.

This is a neat little academic stiletto. As Brooks' last sentence suggests, Kermode had clearly, in his presence, mocked the scientific practices of his predecessor, Fannin, no doubt as a comparison to his own immaculate scientific accuracy. Now his own ploy was turned against him. "So," Brooks concluded, "before admitting the Plumed Egret to the North American list (in which case it would be by far the most extraordinary straggler that has ever found its way to this continent), it would be as well to take into account the evidence here submitted."

Whether or not this particular specimen was a substitute can never be determined now, but it is clear that bad blood had existed between Kermode and Brooks for some time. In a letter from Brooks to Dr. Joseph Grinnell of Berkeley, written in 1917 and quoted in Hamilton Mack Laing's *Allan Brooks: Artist, Naturalist*, Brooks said, "To keep Francis Kermode in Victoria is almost a crime."

In 1928, a well-known name reappeared in the Museum.

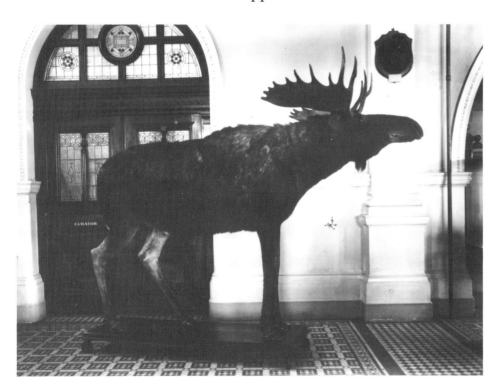

This moose, probably the one illustrated earlier to demonstrate techniques of taxidermy, stood in the foyer of the East Wing for several decades. In the end it was retired because of the numerous bald spots caused by generations of visitors stroking its hide.

73

Crossroads

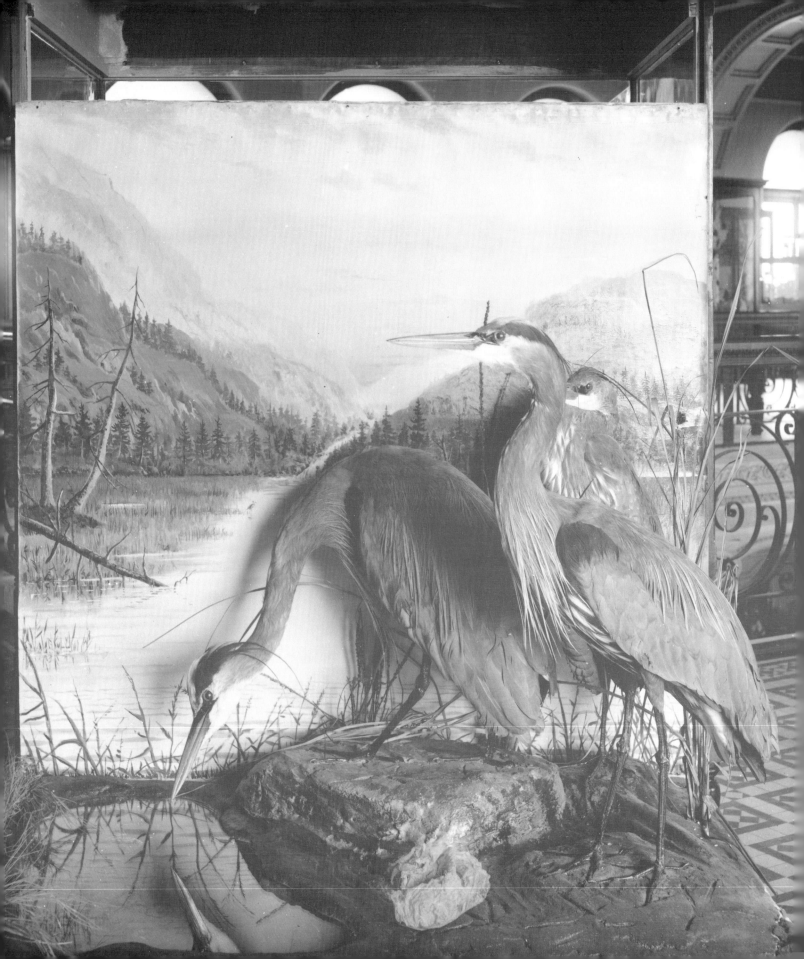

Crossroads

A Decade Free of Strife and Controversy

The decade between the end of World War I, when
E. M. Anderson was fired, and 1928, was relatively tranquil for the
Museum. There is little evidence of any strife or controversy. The
staff, assistant biologists Ernest Blackmore, William Carter and
George Hardy, and recorder Winifred Redfern worked in evident
harmony (perhaps even a little more than harmony; Winifred
Redfern later became Mrs. George Hardy). The collections increased
modestly because the number of field trips were few. We learn, too,
that the specimens collected on these trips were not always curated.
The biology assistant appointed in 1935 discovered the specimens
Kermode had collected on his field trip to Atlin, reported in the first
Annual Report of 1913, mouldering in the basement of a building
next to the then King's Printer office. And although Kermode
complained almost ritually in his annual reports about lack of space
(to which the government responded in 1921 by having the
basement of the East Wing excavated), he never seems to have made
a determined effort to gain any additional staff. Indeed, there are
hints of pride that he was able to run the Museum with so few
people.

By 1928, however, the situation had begun to deteriorate so
seriously that Kermode was forced to do something about it. Moths
and other insects were ravaging both specimens and artifacts, and
the cataloguing of the collections was so far in arrears as to be
beyond remedy by the existing staff. Perhaps Kermode's reluctance
to push for more staff indicates that he was uneasy about the advent
of a more academically qualified subordinate. And the person he
chose tends to support that suspicion. He was academically
unqualified but had impressive practical experience.

*Francis Kermode, every inch the
Director, although at the time this
photograph was taken he was still
called the Curator.*

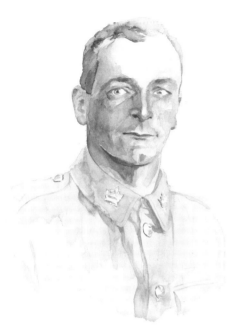

William Newcombe

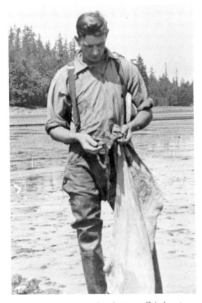

George Hardy, Assistant Biologist in the 1920s.

Newcombe, a Name to Remember

W. A. Newcombe (invariably referred to as "Billy"), son of the celebrated Dr. C. F. Newcombe, was appointed as an assistant biologist in June, 1928. Billy, who was 28 at the time, appears to have had a sporadic education and no formal training as a biologist or anthropologist, but he had begun at an early age to accompany his father on collecting trips. Later, he became more and more involved in his father's work, entering into correspondence with his father's scientific contacts, first as a secretary and later with his own interpretations and scientific contributions. By 1928, in spite of his lack of formal education, Billy Newcombe had a considerable reputation in his own right.

The appointment lasted for four years; and ended in bitter recriminations and public controversy. It put an end to Newcombe's career and damaged Kermode's reputation. According to Newcombe's own account, he had visited Victoria after an absence and made a courtesy call on Kermode,

> when he informed me of his difficulties in carrying on the work, what with his Assistant resigning [George Hardy married Winifred Redfern and returned to his previous vocation: farming in Alberta] and not being in good health. He begged me to join him saying I was the only man he knew, that had a general knowledge of the material in the Museum as well as being acquainted with many of the correspondents and my having collected in various parts of the Province.

Newcombe claims he succumbed to Kermode's pleas with some reluctance, taking care to sever his business connections before accepting the post, and thereafter toiled relentlessly for the next four years to restore order from something approaching chaos.

Unfortunately, friction between the director and his new assistant surfaced after a year or two. Friends, associates and correspondents of both the elder and younger Newcombe began to renew their contacts with the Museum, largely ignoring Kermode as they did so. And Kermode, always jealous of his prerogatives as director, became increasingly resentful. By 1932, things came to a head. Letters were arriving at the Museum addressed to W. A. Newcombe, Director. It is impossible to tell whether this was a simple error or a deliberate attempt to slight Kermode, who had never been popular with the scientific establishment of his day.

Understandably, Kermode took steps to change things. Newcombe's official position was as assistant biologist. Kermode construed this to mean assistant to the director; therefore, all correspondence to the Museum must be addressed to the Director, to pass on to his staff only if he decided to; and all outgoing correspondence from the Museum must leave under his signature, no matter who wrote it. The same thing applied to scientific publications: no matter who wrote them, they would bear Kermode's name. It should be noted that, with correspondence, this was not an unusual practice at the time; with scientific publications, a director's name might appear, but not as author. In any event, Newcombe appears to have resisted, if not actually ignored, this dictum, and eventually Kermode asked for a memo from P. Walker, Deputy Provincial Secretary, to this effect:

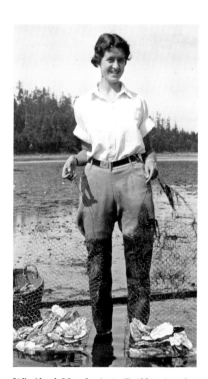

"On October 12, I gave Mr. Newcombe a memorandum in regard to this matter. Of which he has taken no notice, but told me I was batty and off my head."

Sir, October 11, 1932

The matter of the handling of official mail has recently come before me, and this is to advise you that all mail not marked private should be opened in the first instance by some member of your staff nominated by you. Letters should then be recorded and in every case laid before you for action.

Out-going mail should also in every case be seen by you before being placed in the mail. Copies of all out-going letters must be attached to the file, and, in fact, it is usual to prepare an additional copy of out-going mail and record it separately, and I suggest that this practice be followed in your office.

Walker did not actually suggest that all outgoing mail had to be signed by the Director, but in his own memo to Newcombe dated the day after Walker's, Kermode demanded that "all outgoing mail [is] to be type-written with two copies, one attached to the files and one in the letter book. Letters written to be initialed by the stenographer and the person writing the same and submitted to the Director for signature." In a subsequent memo to the Provincial Secretary, S. L. Howe, Kermode complains that "On October 12, I gave Mr. Newcombe a memorandum in regard to this matter. Of which he has taken no notice, but told me I was batty and off my head."

Winifred Hardy (née Redfern), who later replaced her husband as Assistant Biologist.

\mathcal{A}nother contentious issue was the writing and publication of the 1931 *Annual Report*. Newcombe had been responsible for assembling and editing all the material not contributed from outsiders, and Kermode had evidently re-edited some of it, introducing, in Newcombe's opinion, some substantial factual errors. Since there is no record of what was edited, we cannot judge who was at fault in this instance, but it provided more fuel for a confrontation between two increasingly entrenched antagonists. Kermode now found other reasons for complaint, one of which had to do with office hours. Once again he solicited a memo from Walker, which was forthcoming:

> . . . in all the Departments and Sub-departments of the Civil Service . . . all employees must adhere strictly to the time of arrival and leaving.

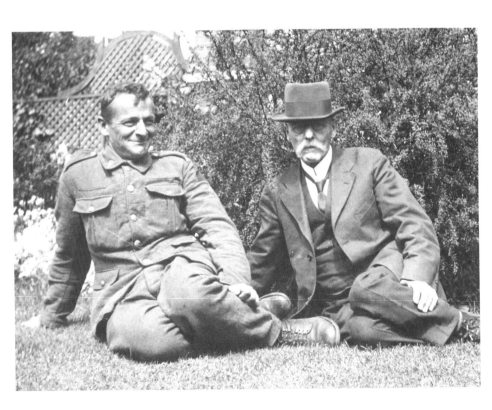

Dr. C. F. Newcombe and his son Billy. The solid reputation of the father and the growing reputation of the son may have been the real cause of the confrontation between Billy and Francis Kermode.

. . . you [are] to notify all persons under your control that they must be in their offices not later than 9 a.m. and must not leave until 5 p.m.

The two men had now reached the stage at which they did not talk to each other; instead, they communicated by memo. Newcombe responded on October 27:

> It will be noted that the undersigned is often a few minutes late in the morning but owing to the necessity of keeping up the wild flower exhibit and securing food for the live frogs during my own time, I sometimes delayed in securing the necessary material.

Kermode had several other complaints to make about his assistant. "From time to time specimens have been brought in and have been listed by him and put in their places without referring to me in any form. I have been asked in regard to these specimens and was unaware they had even been brought here." Furthermore, "He also had a bird meeting of the Natural History Club from Duncan in April last, which was held in the Museum bird storage skin [sic] room in the basement. This was unknown to me though I was in my office at the time. After the meeting several members spoke to me, asking why I did not attend the meeting with them, and I had to inform them that I knew nothing about it."

The next charge Kermode levelled against Newcombe was considerably more serious. He accused him of removing artifacts from Museum display cases. In support, Kermode even took a deposition from the unfortunate attendant.

> I, H. W. Hart, the Attendant at the Provincial Museum do hereby declare, that I saw W. A. Newcombe the Assistant Biologist in the Provincial Museum remove from a case on the main floor of the Museum, on Saturday afternoon October 15, 1932, the following specimens:-

Ten artifacts are listed, complete with their accession numbers. The fact that the attendant was able to provide these numbers suggests that the deposition was tutored by Kermode. And although Kermode knew very well that the artifacts in question were on loan from Newcombe's own collection, this, like the signing of correspondence, was a grey area. Newcombe should surely have advised his director that he was repossessing his artifacts. Kermode's memo to Newcombe, but for a sarcastic comment about office hours, was not unreasonable, pointing out that the appropriate course of action would have been to apply to him, as director, for the return of the artifacts.

Newcombe's reply, written in pencil, was hardly designed to mollify his Director.

> On Saturday p.m. the loan specimens were removed by me from the case you mention. The receipt you gave me being placed in the Anthropological Catalogue with the other loan lists.
>
> I fully know what the office hours are, but you probably have noted, that the contents of many cases have been rearranged by me after hours, also that I have taken home from time to time specimens to repair. One specimen a hair seal skull (found by me at Becher Bay, in my own time) still being at my residence.

Kermode had instructed Nancy Stark, the stenographer, to lock up all incoming mail if he was out of the office when it arrived.

A Point of No Return

By now things had reached a point of no return. Kermode had instructed Nancy Stark, the stenographer, to lock up all incoming mail if he was out of the office when it arrived. Not unnaturally, Newcombe suspected that some of his mail was being kept from him (as indeed, it may have been) and he appears to have become increasingly intransigeant. The government, aware of Newcombe's popularity and reputation in the museum and scientific communities, yet feeling bound to support authority, took refuge in the familiar excuse of economic restraint. On March 11, 1933, the Provincial Secretary, wrote to Kermode.

> Dear Sir,
>
> As you are aware it has been necessary to make severe curtailments in the estimated expenditures for the ensuing fiscal year, and the Executive council have found it needful to eliminate the position of Assistant Biologist, which is under your control. You will please explain to Mr. Newcombe, the holder of this position, that no funds will be available for the payment of the salary during the ensuing year, and that consequently his services will not be required after the end of the present month. At a later date, if conditions warrant, I hope that it will be possible to reinstate this position.

Proof that this was a clear fabrication was provided in a later memo by Kermode to G. M. Weir, who followed Howe as Provincial Secretary: *"Re W. A. Newcombe.* The reason he was discharged was because he would not conform to the rules and regulations of the Department; also he violated the oath of office taken by Civil Servants." This memo was written in 1936, suggesting that Kermode was still under fire for the dismissal of such a reputable employee.

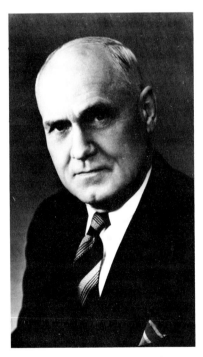

Dr. George Weir, Minister of Education and Provincial Secretary in the Tolmie and Pattullo governments.

The government, and particularly the Premier, had received a disturbing number of complaints, both from influential individuals as well as scientific bodies, some of them from Britain and the United States, as well as other parts of Canada. Most were couched in formal language and nearly all implied some measure of disbelief that economy was the real reason for Newcombe's departure.

A Rotten Joke

*L*etters to the newspapers, on the other hand, were far less restrained:

> To the Editor [*Victoria Daily Times*, August 3, 1933]:- We, the citizens of the Queen Charlotte Islands understand that W. A. Newcombe has been dismissed from his position at the Provincial Museum. This we think is a rank injustice to Mr. Newcombe, as there is no better man in Canada qualified for this position than Mr. Newcombe.
>
> We are told that the government's excuse is economy. What a rotten joke. When we see all the money that is squandered by the Bennett [Federal] and Tolmie governments

Another letter to the *Victoria Daily Times*, dated July 5, 1933, was equally outspoken:

> I understand that the Tolmie Government, that seems to be dismissing everybody but itself, has now dismissed Mr. W. A. Newcombe, assistant biologist at the Provincial Museum, on grounds of "economy." Why doesn't it dismiss the museum and the legislative buildings, too, and be done with it?
>
> But this latest act of stupidity on the part of a government notorious for its stupidities and extravagances, will not be allowed to pass lightly, for the people are up in arms about it, knowing Mr. Newcombe to be of too much value to the country and irreplaceable For when this government that dismissed an asset so much more valuable than itself, is wrapped in a merciful obscurity after September, we have no doubt that Mr. Newcombe will be begged to return to office.

The uproar was considerable and the government put the best face on a bad situation. Yet one senses that although Kermode, with their support, may have won a battle, he had not won a war. By adopting the excuse of economic restraint, the government had, as Newcombe bitterly complained, avoided having to investigate the

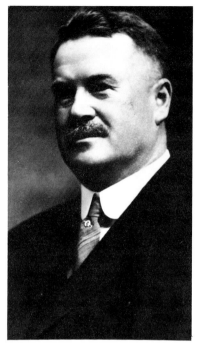

Premier Simon Fraser Tolmie.

"We, the citizens of the Queen Charlotte Islands understand that W. A. Newcombe has been dismissed from his position at the Provincial Museum. This we think is a rank injustice to Mr. Newcombe, as there is no better man in Canada qualified for this position than Mr. Newcombe."

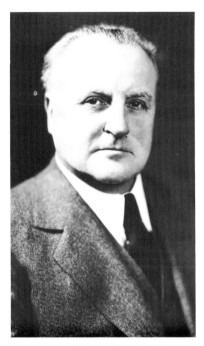

Premier Duff Pattullo, who bore the brunt of the criticism over Billy Newcombe's dismissal.

seriousness, or even the validity, of the complaints Kermode had made against him. Newcombe was never even allowed an interview with the Provincial Secretary so that he could attempt to refute Kermode. He concludes a long and distressing letter of justification by offering to return at a reduced salary, but only "providing the present Director is Superannuated, as the above statements on a thorough investigation will prove him to be an incompetent 'figure head' retained at a large salary at a time when every effort is being made to economise by the present executive of the B.C. Government."

The Bitterness of Defeat

The government responded to the outcry with vague assurances of reinstatement when the economy improved. The new government of Premier Pattullo was still doing so in 1936. The Skidegate Inlet & Moresby Island Liberal Association wrote to Pattullo on June 1, 1936:

> Dear Sir:-
>
> We understand that Mr. W. A. Newcombe . . . is not reinstated at the Prov. Museum in Victoria, as he was promised prior to the Election. Mr. Newcombe is a pioneer of the Islands and we are very disappointed that he has not been reinstated long before this. We would like to request that you do all you can for Mr. Newcombe.

Nothing came of it, and Billy Newcombe, embittered by the experience, became a virtual recluse for the rest of his life, living as a near neighbour to Emily Carr in James Bay. He used to do odd jobs for her, maintaining her bungalow. In return, she gave him paintings — paintings that were found after his death piled up in a considerable heap on the floor of his own house.

84

Four Men from UBC

 n 1935, the position of Assistant Biologist was reinstated, but the appointment did not go to Newcombe. Dr. Weir, the Provincial Secretary, appears to have made a unilateral decision to improve the calibre of junior civil servants entering the government at the time. He brought four people over from the University of British Columbia, all recently graduated and all of whom turned out to be much more than merely competent: they were unusually talented and, each in his sphere, went on to a distinguished and influential career.

"We understand that Mr. W. A. Newcombe . . . is not reinstated at the Prov. Museum in Victoria, as he was promised prior to the Election."

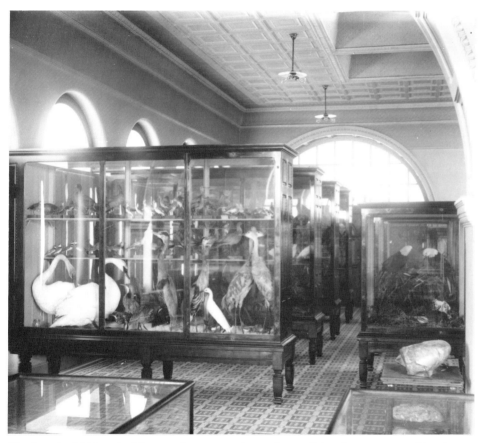

During the 1930s, the Museum began to take on the traditional appearance of its times: row upon row of glass cases.

The first of these appointments was Dr. W. Kaye Lamb, who became Provincial Librarian in 1934. Lamb returned to the University as their Librarian in 1940, eventually moving to Ottawa, where he became Dominion Archivist and, in time, one of Canada's foremost historians. The second, Dr. George Davidson, became Director of Welfare in the Provincial Secretary's department, and went on to become federal Deputy Minister of Welfare in Ottawa and, eventually, head of the Canadian Broadcasting Corporation in 1968. The third, Dr. Harry Cassidy, who also began his career in the Welfare Branch, went on to become a professor at the University of Toronto. The fourth recruit into government ranks, appointed to fill the vacancy as an assistant biologist in the Provincial Museum, was Dr. Ian McTaggart Cowan; and the manner of his appointment was both interesting and significant.

Ian McTaggart Cowan

McTaggart Cowan came to Canada from Scotland in 1913, when he was three years old. His family settled in North Vancouver. He entered the University of British Columbia in 1927, graduating with a Bachelor of Arts degree with first class honours in zoology and botany in 1932. Cowan then enrolled in a Ph.D. programme at the University of California at Berkeley. In 1935, when he had nearly completed his studies, he received a letter from Charles McLean Fraser, head of the Department of Zoology at the University of British Columbia and Cowan's mentor. Fraser asked him if he had any prospects of a job. This was still in the middle of the Depression and Cowan wrote back to say that he had tried everywhere, including the American Museum of Natural History in New York, but the prospects looked grim. In his second letter, Fraser advised Cowan that there was a vacancy at the Provincial Museum and that he should apply to Dr. G. M. Weir, who was Minister of Education as well as Provincial Secretary.

Cowan then wrote to Weir, and followed up with the application form, letters of recommendation and transcripts requested. "In due course I had a letter from Weir saying that the job is yours; show up in my office as soon as you can conveniently get back from Berkeley." Cowan completed his studies in May, 1935, and his mother, his fiancée, Joyce Racey, and her family, travelled down to

California where they had "a big do" after the graduation, including a trip by car into the Mohave Desert. On his return, he went at once to report to the Minister, who passed him to his deputy, P. Walker. Cowan recalls his initiation at the Museum:

> Walker phoned Kermode and said the new biologist is here and we would be coming directly over. Well, Kermode wasn't even aware that they had been looking for anybody and by the time I got to Kermode's office, which was about two and a half minutes later, he was gone. He wouldn't face me. He wasn't consulted. They knew that he had had a conflict and that part of his conflict was an insecurity. He had no training whatsoever; he had come in as an apprentice taxidermist. It was only then I realized I was entering a situation that might be difficult.

As a consequence, Cowan was greeted by Kermode's secretary, Nancy Stark,

> . . . who showed me around and we had a pleasant chat. Instinctively we liked each other and respected each other's areas of competence and went on from there. There was another person in the Museum at that time, Ed Cooke, who was the general handyman. He used to guard the door, dust the cases, was an absolute mine of information. He was called an Attendant, a great fellow who had been all over the world as a sailor before the mast in sailing ships. He and I got along very well together. I was interested; I took a look at the Museum and it was just in pathetic shape. There was no catalogue of any of the material; most of it had not been kept fumigated so many of the specimens were in poor physical condition. There were, though, some bright spots. The anthropology collection was well ordered and generally in good condition, probably as a result of Newcombe's work. There was also a good synoptic collection of mounted birds. These had been well done and were displayed in sound, dustproof cabinets.

. . . by the time I got to Kermode's office, which was about two and a half minutes later, he was gone.

No longer does he speak with a clear voice as a conservationist . . .

An Embattled Dinosaur

The picture of Kermode that emerges in the late '30s is a sad one. No longer does he make collecting trips to Atlin, or journey to the Queen Charlotte Islands in search of the rare and elusive Dawson's caribou. No longer does he speak with a clear voice as a conservationist, as he did during the sea-lion controversy before the First World War. Gone are the heady days of *Ursus kermodei* and his battles with the ornithologists about the Snowy Egret. He appears instead as an embattled dinosaur, doing little or no collecting, even less writing, barren of new ideas, constantly on the defensive

against intruders into *his* museum. Cowan recalls that "he was not a well man; he had terribly bad sinuses and he was in a lot of pain. He wasn't sleeping well at night. His wife died at about that time. He was over 60 and he was sort of an unhappy chap."

Evidently Cowan did not experience the same problems as Billy Newcombe. Kermode did not attempt to insist that all outgoing mail had to be signed by the Director.

> My situation was different. I was appointed by the Minister on the recommendation of recognized authorities in the field. Kermode had nothing to do with the selection. I remember thinking that it was rather a shabby way to treat the Director of the Museum; but I imagine the Deputy Minister had a pretty clear insight into what the problems were and wanted to put the Museum on a new course.

> In general, I found him to be a pleasant fellow. He had been asked to do a job and had been doing it up to a point. He had lost interest and had not kept up to date — the nature of Provincial Museums and their roles in the community had changed but he either did not know that or had lost the enthusiasm for trying.

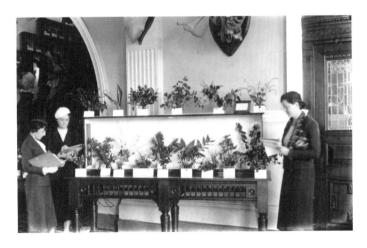

The Carnegie Lectures, initiated by Kermode in 1934, and given fresh impetus by the new assistant, Ian McTaggart Cowan, were popular and widely reported in the press.

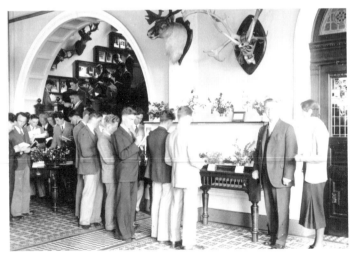

*C*owan, on the other hand, had taken his training in the Museum of Vertebrate Zoology at Berkeley, at that time "one of the great institutions of the world in terms of systematic collections." Furthermore, ". . . this was my first job and I was full of enthusiasm. Even though the collections had been neglected, there was good basis for a fresh start." Taking care to keep Kermode informed, he went about the task of reversing years of neglect. Shortly after his own appointment, an artist, Lillian Sweeney was hired. Encouraged by Cowan, she quickly acquired a variety of museum techniques. Many additions were made to the collection of

Taking care to keep Kermode informed, he (Cowan) went about the task of reversing years of neglect.

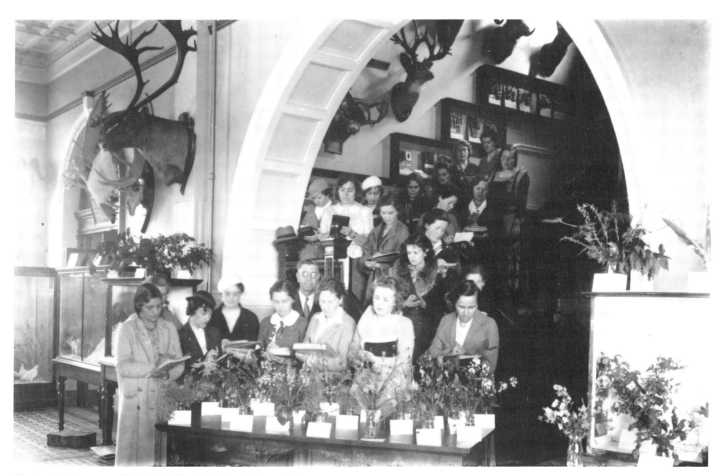

Fresh plants were collected to illustrate the botany lectures.

models of native fishes. Cowan did the casting from fresh specimens using the latest technique of a beeswax mixture (this was before the days of plastics) and Sweeney coloured them accurately. She produced models of three species of fossil elephants, the remains of which were being recovered from the cliffs of James Island and Island View Beach. She helped also with the development of a small tide-pool section and with the production of replicas of amphibians and reptiles for the display collection. As he recalls:

> My analysis of the situation was that, apart from cataloguing and curating the collections, the Museum's most important opportunity was in getting out into the province and studying the great diversity of living animals and plants to be found there. Preliminary lists of the birds and mammals had been done by Fannin and published in 1891 and 1893. Allan Brooks and Harry Swarth had updated the knowledge of the birds in the province in 1925, but much of the province was biologically unknown and the collections did not exist to provide the basis of "modern" identification.

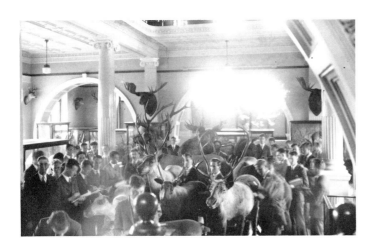

Vertebrate zoology lectures had to rely on the familiar stuffed and mounted animals.

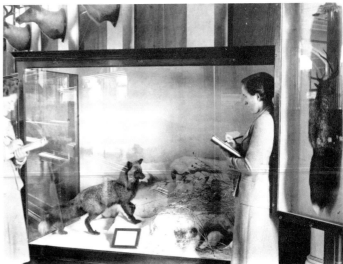

90

However, the first task was to review the existing collections, initiate the cataloguing and see that all the fragile material was properly curated.

At the same time, I tried to introduce a few small mammals which were of a different quality to those available — the old stuff that Fannin had done to the order of the day. They were quality stuff for the 1890s but this was the 1930s; things had changed. I tried to find the small number of unique specimens which were there. For instance, we had had two good skulls and part skeletons of the very rare Dawson's caribou in the Queen Charlotte Islands, which were probably extinct at that time. Kermode had gone up on a hunt for some and I think two of the specimens were shot [though not by Kermode], one that's mounted. But the material had been neglected; the skulls were badly damaged. This was tragic. They were unique specimens; the only examples in the world of a now-extinct species and they had been destroyed by neglect.

A Whale of a Task

*I*n April, 1936, Ian Cowan and Joyce Racey were married. Joyce's father, Kenneth Racey, was one of the province's leading naturalists and an authority on birds. She had grown up to become a competent naturalist in her own right; thus the Museum now had a two-person team for the price of one (as was to happen again when Clifford Carl became director: his wife, Babs, was a qualified marine biologist).

Many evenings and weekends were spent by the husband-and-wife team working on the Museum collections. A notable adventure tackled by them was the dissection of a whale. In August, 1937, a Minke whale blundered into the salmon traps at Sooke and drowned. Cowan received a 'phone call asking if he wanted the carcass. He did, and on the following day it was delivered by barge to the inner harbour in Victoria. This happened on a Saturday, a warm one, which meant that immediate action was required. The Cowan team went at it. By nightfall the animal had been carefully measured and then dissected and the skeleton moved to the Museum's small laboratory on Superior Street, where the laborious and odoriferous task of cleaning and degreasing occupied several days.

Later Cowan, assisted by Ed Cooke, assembled the skeleton and put it on display as the Museum's first whale.

By nightfall the animal had been carefully measured and then dissected and the skeleton moved to the Museum's small laboratory on Superior Street, where the laborious and odoriferous task of cleaning and degreasing occupied several days.

91

Another early achievement, in 1936, was procurement of the Museum's first vehicle. Cowan, eager to begin his field work, started to push for it. Kermode advised him that it was a waste of time to apply for the required $1600 but Cowan persevered and the Museum acquired a Chevrolet panel truck which had previously served as a laundry van.

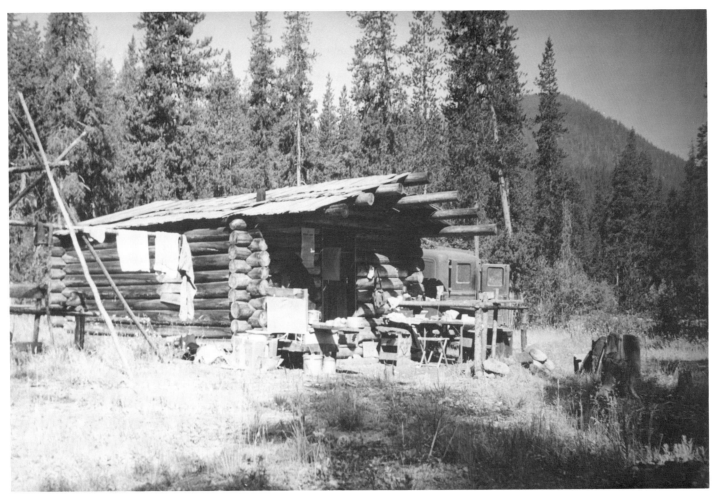

A Forest Service cabin used for many seasons by staff on collecting trips. The back of the Museum's first van can be seen to the right of the cabin.

Youth and Energy Equals New Energy

*D*uring the next four years field trips were carried out in the Anarchist Mountain area, Monashee Pass, Ootsa Lake and the Peace River district, among several others. Spurred by the youth and energy of Cowan, Kermode began to take a renewed interest in the Museum. According to Cowan, the school programme was jointly conceived and became an important part of the Museum's activities. With financial aid from the Carnegie Trust, of which Kermode was the western museums representative, part-time help was hired and school programmes in natural history and anthropology were offered on Saturday mornings. The newspapers gave extensive coverage to this new development. Kermode gave lectures and, by all reports, they were popular and successful. Furthermore, travelling kits were created to be distributed amongst the schools — the Museum's first venture into travelling exhibits.

Meanwhile, Cowan began to open up lines of communication with other biologists on Vancouver Island and on the mainland, dealing for the most part with game wardens who, although they had no formal training as biologists, gave assistance with the collecting of specimens. He did a good deal of scientific work on the Island deer population. A letter to A. Monk, game warden in Alberni, written in March, 1937, is typical of the web of contacts he was creating:

> You are indeed a man of action. The express man is considering putting us on his regular route. But all joking aside I cannot tell you how much we appreciate the elk and otter specimens recently sent down by you.
>
> You will no doubt think I am absolutely insatiable, but if from time to time you should encounter further skulls of elk or of any of the predators, that you are willing to let us have we will greatly appreciate any cooperation you would be able to give

Rockabella

*I*n 1936, Cowan wrote to the secretary of the Canadian Museums Committee, applying for a Carnegie Corporation Scholarship to visit museums in Ottawa, Toronto, New York, Washington and Chicago. The scholarship was granted and, the following summer, he made the journey, returning to Victoria brimming with ideas and ambition. Unfortunately, the Depression was still very much a fact of life and, with limited resources, few of his new ideas could be implemented. As well, he was missing contacts with other biologists, his isolation relieved only by the company of W. Kaye Lamb, the Provincial Librarian who, with Cowan, had resided at the celebrated Rockabella. Lamb describes it as:

> . . . a famous institution . . . on the corner of Blanshard Street, just about where the three roads come together at the foot of Quadra. It was a big old frame building built in the 1880s by a Swiss couple as a European-style private hotel. It had been taken over by a Mrs. Tuck, and in my day was managed by her daughter, Isla, who was a schoolteacher and continued to run it as a superior boarding house and it was an incredible place. It had no central heating, there was only one bathroom on each floor. But it was a very comfortable place and most people came to stay forever. When Ian [Cowan] arrived, he came there; Ian stayed there only for the year before his marriage. I stayed there for nearly four years but, while he was there, we were in and out of one another's room.

Dr. Lamb, The Provincial Library and The Museum

*D*r. Lamb played a role, even though it was an indirect one, in the history of the Museum; some of the artifacts he collected now reside in the Museum. Born in New Westminster, he earned his bachelor's degree in History at the University of British Columbia, winning, at the same time, the Nichol Scholarship, which made it possible for him to study in Paris for three years, after which he went on to London where he received his Ph.D. degree in 1933. Returning to the University of British Columbia, he taught for a short period in the History Department, before being appointed Provincial Librarian and moving to Victoria in 1934.

Unfortunately, the Depression was still very much a fact of life and, with limited resources, few of his (Cowan's) new ideas could be implemented.

The Provincial Library, later the Provincial Archives, from its inception at the turn of the century until 1967, was responsible for the preservation not only of historical documents and visual records, but of non-Indian artifacts as well. These were turned over to the Museum in 1967 when the new *Museum Act* specified modern history, as well as natural history and anthropology, as the Museum's mandate. When Lamb was appointed, there was evidently no specific policy governing the collection of artifacts; consequently the collection, which was both small and eclectic, was kept in one room of the Library, and the Librarian was concerned more about its safety than with any attempt at public display. Lamb, with characteristic energy, set about the task of improving the collection.

Dr. W. Kaye Lamb, one of George Weir's bright young men. Like McTaggart Cowan, he went on to a distinguished career. He became the Dominion Archivist and one of Canada's foremost historians.
(*Public Archives of Canada*)

Tolmie's Griddle-iron

He recalls one sortie he made to the residence of S. F. Tolmie in 1936 to seek the loan of an artifact for an exhibition on the old Hudson's Bay Company paddle steamer, the *Beaver*, which he was preparing. Lamb was aware that Tolmie had a griddle-iron fashioned from one of the plates from the original boiler, replaced fairly early in the *Beaver's* career, and he wanted it for his exhibition. Tolmie seemed determined not to part with it so, with a last rueful glance at the artifact, Lamb left and began to walk down the steps to the path leading to the front gate. Tolmie, until recently Premier of the Province, had evidently changed his mind. Following Lamb out onto the verandah, he called him back. Holding up the griddle, he said: "Young man, if anything happens to this, something will happen to you!" and handed it to him.

During this visit, Lamb also observed that Tolmie had in his dining room a table and six chairs which had once graced the dining hall in Fort Victoria. When Tolmie died in 1937, the contents of his home were put up for auction, but Lamb was able to negotiate successfully with Tolmie's heirs to purchase both the furniture and the griddle-iron for the Library collection.

To Lower the Chairs or Not to Lower the Chairs?

On another occasion, Kermode sought Lamb's advice on what he considered a difficult acquisition. Thomas Watson, the president of International Business Machines (IBM was a considerably less monolithic corporation in the '30s and Watson was very much running the company), had purchased paintings from an artist in each of the 48 states for an exhibition at the New York World's Fair. Now he had decided to purchase paintings from a Canadian artist in each of the nine provinces to augment this gesture, which had proved a great success. Watson wrote to Kermode, asking him to make the choice of the painting for British Columbia and to negotiate the price with the artist. Kermode was alarmed that, if he resorted to the newspapers to solicit a painting, he would be inundated with submissions.

Lamb, on the other hand, had no such anxieties. He pointed out that Emily Carr was in his opinion the most gifted artist in British Columbia; it would simply be a matter of choosing the particular painting and negotiating a price with her. He and Kermode arranged to meet Carr, advising her of the purpose of their visit. Lamb looked forward to the meeting with some interest. The first time he had met Emily Carr she was living in the house that became famous as the "House of All Sorts". On that occasion, he observed, as they entered her living room, that all the chairs in the room were hanging on ropes which passed over pulleys screwed into the ceiling. If the occasion was to be a social one, the chairs were lowered to the floor; if not, they remained in the air. Emily Carr made no move to lower any chairs; consequently, Lamb recalls dryly, his first visit was a brief one.

A $400 Investment in an Artist Called Carr

By now, however, Emily Carr was living in a cottage in James Bay and the meeting went smoothly. When the choice had been made of the painting Lamb considered most suitable, he noticed that a price of $400 had been pencilled on the back of the canvas. Suspecting that Carr had never received such a handsome price for any of her paintings before, he asked her if that was really the price she was asking. Carr looked at him with what Lamb describes as an enigmatic expression on her face. "Yes," she replied firmly.

As Kermode and Lamb walked back to the Legislative complex, Kermode complained that it would be a waste of time to write to IBM with such a steep price; but Lamb persuaded him to persevere. Kermode was right. Watson wrote back, requesting more negotiation leading to a significantly reduced price. Lamb refused to accept this and wrote a persuasive supporting letter, pointing out that Emily Carr was so talented, her paintings were bound to appreciate handsomely in the years to come. Watson capitulated and bought the painting for $400.

Emily Carr, the eccentric but superbly talented artist who became a close friend of Billy Newcombe in his reclusive years.

(E. Hembroff-Schleicher photo)

The Heyerdahl Interlude

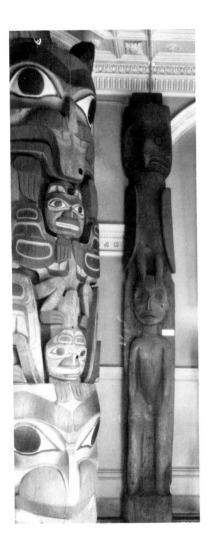

One small footnote to the history of the Museum was written in 1939, when a 25-year-old Thor Heyerdahl stepped off a freighter in Victoria with his wife after a honeymoon in the Marquesas Islands. The War made it impractical for him to return to his native Norway and, for some months, Heyerdahl was given space to work on the other end of Cowan's spacious desk. Cowan recalls that he was already formulating his theory of an Asiatic migration through the British Columbia archipelago — he was collecting words common to the languages of the Northwest-Coast Indians and the Polynesians — which resulted eventually in the celebrated Kontiki expedition.

Contact with a "Strong Team"

Apart from the company of Lamb, there was what Cowan described as the only other group of biologists on Vancouver Island, the staff at the Biological Station in Nanaimo, whom he characterized as "a strong team": Andrew Pritchard, Earl Foerster, and John Hart. The Director was W. A. Clemens. Every Friday afternoon at four o'clock, this group would meet to hold a scientific seminar and Cowan tried to schedule his work up Island to coincide with these seminars. But it was his friendship with Lamb he found most valuable, and Cowan recalls that it was Lamb who served as a 'safety valve' when frustrations at the Museum tended to become too provocative. "He was a very wise individual and he worked very close to the seats of power in the government, so he was a good counsel."

Kaye Lamb recollects the relationship between Kermode and Cowan as being rather less harmonious than Cowan remembers:

> . . . It was incredible, you know; I was there beside him [Kermode] for six years and yet I know very little about his background. We were always friendly in a kind of superficial way, but I never had anything to do with him socially

> But he was not a trained person and Ian tended to be intolerant . . . he found Kermode very difficult and I think he got along simply by ignoring him . . . and Kermode perhaps had the good sense to recognize that he had someone with quite extraordinary ability and he had just better let it go and reap the benefit.

Cowan: Time to Move . . .

ℐn any event, by 1940 Cowan began to feel that it was time to move on. During his term at the Museum, he published more than 20 scientific papers, some through the Museum, and others in various scientific journals. In 1939, the first of a new Museum publication series, Occasional Papers, Number 1, Cowan's *The Vertebrate Fauna of the Peace River District of British Columbia,* was released. Cowan had succeeded also, in spite of bureaucratic objections that it was not feasible, in having the attic area refurbished and opened up to provide six small offices, invaluable space for study and writing, as well as for the preparation of the many speaking engagements he accepted. In short, he did a great deal to revive what had had, a few short years before, the appearance of a dying institution. Yet there seemed little prospect that funds were going to be made available for any significant expansion of space or staff, even if he could look forward to replacing Kermode as Director in the not too distant future. His contacts with the Biological Station at Nanaimo made him yearn for a more congenial scientific atmosphere to work in.

. . . To UBC

Ａnd it was one of these contacts that opened a valuable door for him. He had heard that McLean Fraser was retiring from the University of British Columbia and consulted Clemens, Head of the Biological Station, pointing out that he wasn't aspiring to take Fraser's place as head, but that he would like to join the Zoology Department. Clemens replied that he was going over to Vancouver on the following day to talk to the President, Dr. Klinck, "and I'll tell him that you're interested in being considered, that you're a British Columbian; you're here, you've got a good degree, I know you, and so on" Soon after Cowan reached home that evening, the 'phone rang. Clemens had been visited in his office by Dr. Klinck only a few minutes after Cowan had left. The purpose of Klinck's visit was to offer the position of Head of the Department of Zoology to Clemens. "I told him," said Clemens, "that I would accept providing he took you too."

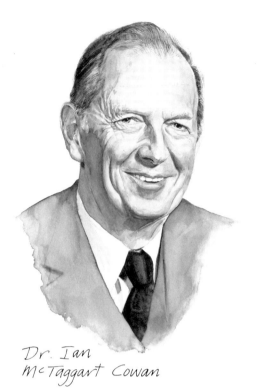

Dr. Ian
McTaggart Cowan

Klinck evidently didn't commit himself about Cowan, but things tended to move much more quickly in those days. Less than a week after his phone conversation with Clemens, Cowan 'phoned Walker, the Deputy Provincial Secretary, to advise him that, if he was accepted at the University of British Columbia, he would be resigning from the Museum in the near future. Two days later, there was a knock on Cowan's office door and Dr. Klinck walked in. That was the job interview. It was successful, Klinck's only reservation being that Cowan would have to accept the same salary as he was getting in the Museum. Cowan was appointed as an Assistant Professor. Within five years he was promoted to full professor, an almost unheard-of leap in promotion for those days. In 1953 he became Head of the Zoology Department, and in 1964 he became Dean of Graduate Studies. More recently, from 1979 to 1984, he served as Chancellor of the University of Victoria.

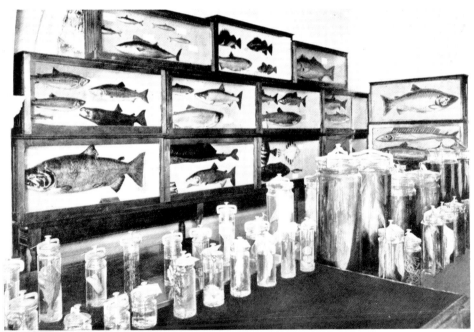

Fish specimens were either mounted in glass cases or displayed in jars of alcohol.

An Old Order about to Change

On hearing of his resignation, Weir, the Provincial Secretary, called Cowan to his office and attempted to persuade him to change his mind, pointing out that Kermode was not far from retirement and the directorship would almost certainly be Cowan's. Cowan had no second thoughts, but the government evidently decided that the time had come for a change at the top in the Museum, because Cowan was asked if he could recommend anyone to replace Kermode as Director. Cowan immediately suggested Clifford Carl, a man he described as being a British Columbian, having a good degree from the University of Toronto, being very competent and who was, at the moment, woefully underemployed at the hatchery at Cowichan Lake.

Cowan left the Museum in August, 1940, coincidentally with Lamb, who had accepted a position as Librarian at the University of British Columbia. Six weeks later, Kermode, who was now 65 years old, retired.

Thunderbird Park?

There is only one more document of Kernode's on file: a letter to the *The Daily Colonist* and *The Times,* thanking various government departments for their co-operation "during the 50 years' of service in the Provincial Museum of Natural History." He goes on to thank the newspapers for their "excellent publicity and reports of the various activities of the Museum," and, intriguingly, thanking "the Committee who have been working with me at the Indian Village at the corner of Belleville and Douglas Sts., Victoria, which is to be an open-air museum known as "Thunderbird Park" a branch of the Provincial Museum of Natural History, the latest work undertaken by this Department."

This latter, suggesting as it does that Thunderbird Park was initiated by the Museum, is an intriguing claim because Dr. Lamb recalls a somewhat different scenario:

> The idea of creating Thunderbird Park did not come from Kermode. Did you ever hear of Tom Parsons, who was the last head of the British Columbia Police? Tom was a fascinating person and he came into my office one day and sat down, as he often did, and said:

"What am I going to do with my totem poles?"

I said,"Where have you got totem poles?"

"They're over in the Provincial Police Armouries; they're just sitting there. I think they should be on display somewhere — they're wonderful."

So he and I began discussing the problem. That was just after I persuaded the government to buy Helmcken House. There was the plot of land between Helmcken House and Douglas Street which was just a wilderness. McTavish, a relative of Dr. Helmcken, was an alderman on City Council at the time and he arranged to have the lot rented out at a dollar a year. I suspect the property still belongs to the City.

So, in fact, the genesis of Thunderbird Park looks very like a re-write of the 1911 project, when Scholefield, the Provincial Librarian, stimulated C. E. Newcombe's collecting activities — and that Kermode became enthusiastic only after the project had been initiated. In fact, the totem poles had been removed from storage in an unsuitable building and transferred to the Armouries building in 1925. They may well have been augmented by some Tom Parsons had collected, but the majority were probably collected by Newcombe. In any case, once Kermode became involved in the project he worked hard to bring it to fruition.

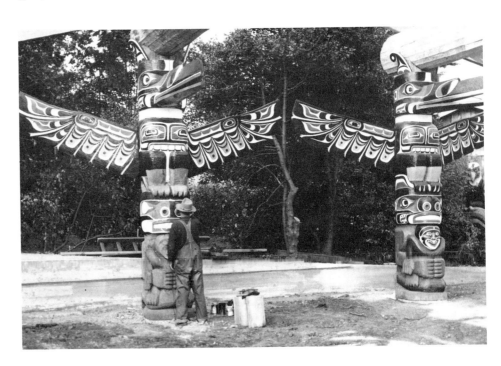

Thunderbird Park, "the Indian village at the corner of Douglas and Belleville Streets," to the east of the present Museum complex, was the joint project of Tom Parsons, Chief Constable of the Provincial Police, Kaye Lamb and Francis Kermode.

102

Requiem

\mathcal{T}hus ended a career of 50 years in the Museum, 36 of them as Director. On the face of it, Kermode tends to look less than impressive; a man constantly on the defensive, quick to take offence, a follower rather than a leader. But as we mentioned before, his apparent shortcomings may have had more to do with the economic and intellectual climate of his times. In his day, British Columbia was still a frontier community, unwilling to commit more than token resources to a museum. In which case, Kermode did an admirable job of keeping the Museum going as a cosy, uncontroversial institution. At any rate, his regime is still remembered by many with affection and often admiration.

Francis Kermode

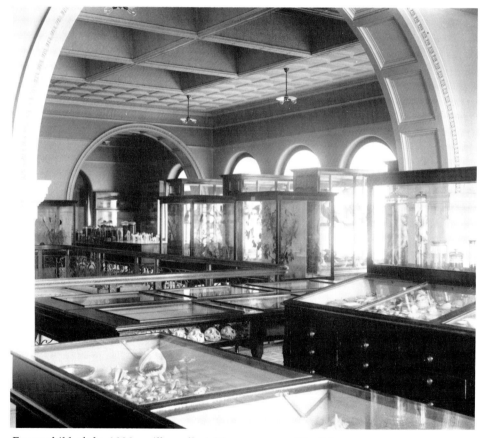

Every child of the 1930s will recall visiting museums like this one.

The Clifford
Carl Years

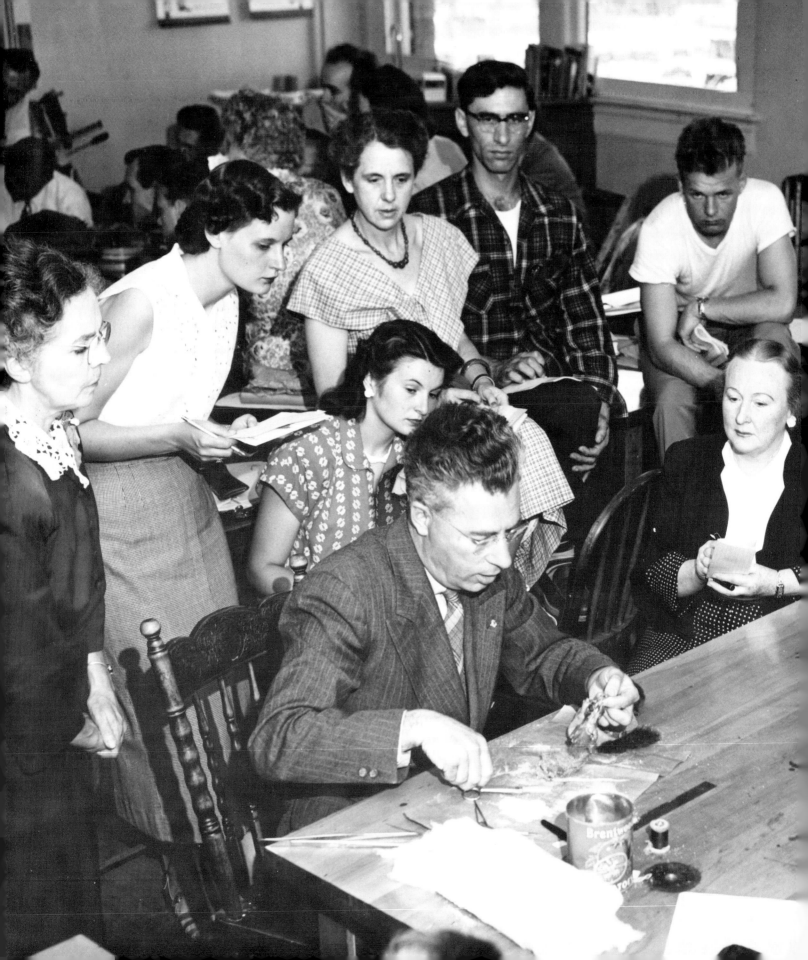

The Clifford Carl Years

The Boy and the Man

Taking the Museum to the people. Carl communicated with the public through all the media and invariably persuaded them that the Museum was both a necessity and a joy.

Clifford Carl was born in 1908, in the Point Grey area of Vancouver which, at the time, was still very much a rural community. Fifty years later, when journalists wrote about Carl it was virtually obligatory for them to report that, when he was a child, his mother had to insist that he empty all the pockets of his clothes of live creatures — ranging from frogs and snakes to crabs and centipedes — before she laundered them. It was the sort of myth journalists find it necessary to invent. The truth seems to be that he was, like the majority of his childhood contemporaries, intrigued by the natural world about him; but Clifford Carl's interest really matured when he entered university and chose Zoology as his field of study.

After attending Kitsilano High, in Vancouver, he studied biology at the University of British Columbia, graduating with a B.A. in 1930 and an M.A. in 1932. From there he went to the University of Toronto, where he earned his Ph.D. in 1937. His university years coincided almost exactly wlth the Great Depression, but Carl succeeded in finding summer jobs to see him through his education. He worked for the Fisheries Research Board, investigating the life cycle and behaviour of oysters in the Ladysmith and Crescent Beach areas. Later, during his post-graduate days, he worked as a laboratory assistant and instructor, both at UBC and the University of Toronto.

After gaining his Ph.D. in 1937, he married Josephine F. L. Hart on October 8, 1938, a fellow Ph.D. and zoologist, who continued, while raising their four children, her own career in marine biology, eventually becoming an authority on marine crustaceans. In fact, Mrs. Carl first worked for the Museum as a student in 1929, when

Clifford Carl was born in 1908, in the Point Grey area of Vancouver which, at the time, was still very much a rural community.

107

Coming to the Museum with a background in marine biology, Carl was never happier than when he was on a boat.

Billy Newcombe hired her, for a fee of $10, to do some research on crustaceans. Forty-two years later, Dr. Bristol Foster, who succeeded her husband as Director, made her an honorary curator in marine biology. In 1937, Carl and his bride moved to Vancouver Island, where he went to work for the Fisheries Research Board as a full-time employee in charge of the Cowichan Lake Hatchery. Two years later, on the recommendation of McTaggart Cowan, he was offered the position of Acting Director at the Museum. His appointment as Director was confirmed in 1942. He remained as Director from then until December 1, 1969, when, after all the administrative burdens of planning and overseeing the creation of the new Museum, he resigned to become Curator of the *Hall of the Sea*, an exhibit that faded into obscurity with the advent of new plans, based on The Ring of Time, which were adopted for the whole display area of the Museum.

The New Broom

Carl came to the Museum full of enthusiasm for his new job. The earliest of his memoranda surviving is to F. R. Butler, the Game Commissioner, asking for a permit to collect fresh-water specimens from all the lakes in the Victoria area. The second, entitled "Organization of the Provincial Museum," written in August, 1940, deals for most of its 13 pages with the procedures for cataloguing, handling and treatment of the collections. There is a comprehensive section on the treatment of mammal specimens. "The skulls if small are cleaned in the bug cabinet or if large boiled and cleaned by Mr. Cooke, the same applies to the skeletons."

"The Bug Colony . . . of dermestid beetles for cleaning skulls and skeletons," receives similarly detailed treatment:

> The Colony . . . is in the steel cabinet in the basement of the workshop. It is kept warm by a 100 Watt light globe burning under a large flower pot. When active work is desired the screened dish of water is placed on top of the flower pot and with the rise in humidity to 100 per cent the dermestids become exceedingly active.

> To keep the colony going some dried meat or a skeleton to be cleaned should be put in as required every three weeks or so when active cleaning is not going on.

There is no mention of the remarkably powerful and fetid aroma produced by a colony of dermestids at work. Perhaps the basement was sufficiently isolated to minimize the problem.

Almost from the beginning Carl brought a new sense of professional competence to the Museum. Cowan had done the same thing before him, but, because he was not the director, Cowan had had to step cautiously. Carl, on the other hand, began what can reasonably be called a house-cleaning. Under *Display Collections*, he has this to say:

> In general it can be said that the display collections need much rearrangement and renewal of much material. This applies especially to the mammal collection which is on the whole very poor. Some are wrongly identified.
>
> The bird collection is good, with certain obvious exceptions but is poorly displayed and in several cases the identifications are incorrect.
>
> The anthropological collection is almost unparalleled but suffers from acute overcrowding. This is largely the result of improperly designed cases and a failure to appreciate the difference between display material and study material
>
> It will be obvious that labelling is the poorest feature of the museum display material. With the exception of perhaps twenty or thirty new labels the entire display collection of every department should be relabelled with labels that tell something about the specimen and how it fits into the scheme of things

Taking the Museum to the Public

*I*n the past, although some thought had been given to display techniques (early experiments with dioramas, for example), a coherent philosophy about how collections should be displayed had failed to emerge. Now, for the first time, some thought was being given to this aspect of the Museum. In February, 1941, Carl wrote another paper, entitled *Proposed Programme for the Provincial Museum*. His first suggestion broke no new ground: service was provided by bringing the public to the Museum; and this was accomplished "by means of attractive exhibits." The second suggestion had hitherto been largely ignored, except by Billy Newcombe and Cowan, who had practised it as far as they were allowed to, "by means of taking the Museum to the public in the form of lectures, travelling exhibits, publications etc."

Almost from the beginning Carl brought a new sense of professional competence to the Museum.

And it was in this sphere that Clifford Carl's stewardship shone with a bright and steady light. He was a born communicator, an expert, indeed a brilliant performer in the media. However, the almost star status he achieved on radio and television came later. To begin with, he revived the school programmes on Saturday mornings, which had been so successful in the Carnegie-funded series of 1934-35. He also encouraged his staff to emulate his own increasingly frequent appearances as a lecturer to local organizations, and almost immediately after his arrival the Museum began to be a familiar topic of conversation throughout the community.

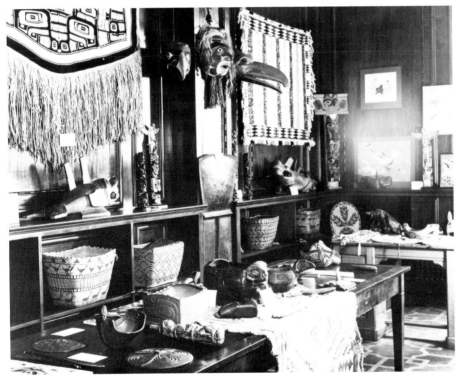

This selection of Indian art and artifacts was displayed in the Provincial Library Reference Room for a writers' convention in 1941.

A More Friendly and Vital Place

Victoria has been variously described as "the place for the newly-wed or the half-dead"; or "the place where old people go to visit their parents." While these ironic judgements have lost much of their sting nowadays, they were not entirely unjustified in the early '40s. There was in fact very little in the way of intellectual stimulation going on at the time, and Carl's efforts to move out to the public appear to have struck a quick and responsive chord. The Museum was all at once a more friendly and vital place under its new director.

For the first few years of his tenure, no doubt because World War II was in progress, there was little increase in staff. In 1941, Mrs. Hardy retired as Botanist, to be replaced by her husband, George (it is difficult to avoid the suspicion that the change in directors persuaded George Hardy to return to his old position). In 1942, the Museum, together with the Library and Archives, were transferred from the Provincial Secretary's Department to the Education Department (it was moved again in 1961 to the Department of Recreation and Conservation). This move is explained in the *Annual Report* as being necessary because "the work of the Museum is being directed more and more along educational lines." There was also that year one addition to the staff. F. L. Beebe, described as an "air-brush artist," was hired in November. In fact, Frank Beebe was a good deal more than that. In 1944, he left the Museum to work in Vancouver's Stanley Park, eventually becoming Curator of its Zoo. Returning to the Museum in 1952, by then recognized as an outstanding wildlife illustrator, he produced some superb backdrops for dioramas.

In 1942, following the Japanese attack on Pearl Harbor, the war loomed over the Museum for the first time.

Botanist George Hardy with a bracket fungus collected in Beacon Hill Park.

Alarms and Excursions

In 1942, following the Japanese attack on Pearl Harbour, the war loomed over the Museum for the first time. There were genuine apprehensions that the Japanese might mount air raids on British Columbia. In fact, the first anxiety was expressed by A. Dixon, Chief Engineer for the Department of Public Works on December 11, 1941, only four days after Pearl Harbour:

> Referring to the possibility of an Air Raid on the City, the question of removal of any of your valuable relics to other possibly more

secure place was brought to the attention of the Premier. He intimates that we exercise our own judgment in this matter.

As we are to be guided by your wishes in this matter, perhaps you will give it consideration and any way we can assist we shall be glad to do so.

Carl was apparently less apprehensive than most; he responded in pragmatic terms:

After considering this matter I feel that unless all our collections are moved to possibly more safe places, which is impracticable, we had better leave them in their present places. There are only a few specimens and other items which are irreplaceable but these might be conveniently stored in the basement.

Nevertheless, some anxiety remained and, in January, H. Anscomb, the Minister of Public Works, introduced security measures: ". . . all persons desiring admission to the Parliament Buildings, with the exception of those already supplied with passes, will be required to present their National Registration cards to the Officer in charge at the door. This does not apply to men in the uniform of His Majesty's Service." And in the Museum itself, Carl issued "Instructions to Museum Staff . . . to be carried out in event of air raid":

On sounding of the alarm all members will proceed to the basement corridor of the east wing of the main building via the underground passage, and will assemble outside [the] office of [the] Purchasing Agent.

Mr. Pegler [Attendant] will be responsible for directing any visitors to this shelter.

In the event of incendiary bombs being used Mr. Beebe and Mr. Hardy, assisted by myself, will be responsible for attempting to smother or remove same by means of sand and shovels provided.

Precautions: Adequate or Otherwise

*I*t is perhaps fortunate that these precautions were never put to the test because, in the 1942 *Annual Report,* the additional equipment listed for this purpose seems remarkably limited. It was "in the form of a sand-box, pail and scoop on the main floor, and a large barrel of water with buckets and stirrup-pump in the attic." As well, "To comply with 'dim-out' regulations which came into effect in the late fall, all windows of the Museum building not already equipped with

blinds were fitted with curtains or covered with tar paper. The skylight has also been covered so that no light can be seen from above." No further mention of the war is made in surviving correspondence, so we must assume that it had little direct effect on the history of the Museum, except to retard its growth for several years.

In 1944, the Museum gained its first Anthropology Assistant since William Newcombe.

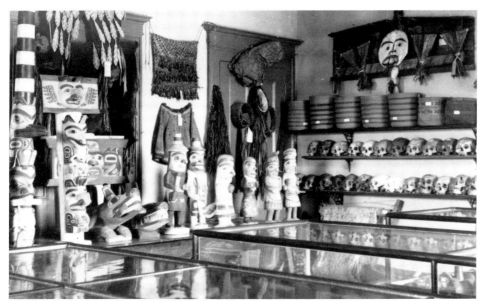

Part of the Anthropology exhibit in the early 1940s.

A. E. Pickford in 1944. He was the Museum's first Anthropology Assistant since Billy Newcombe's contentious departure in 1932.

Some New Beginnings

In 1944, the Museum gained its first Anthropology Assistant since William Newcombe. A. E. Pickford, with a background in botany and silviculture, had been working in the Forestry branch of the provincial government for the past 24 years. He became interested in ethnobotany, researching in his own time and writing what is described as a detailed study entitled, *The Vegetable Foods of the Indians of British Columbia*. This led to a recommendation from his own minister to the Minister of Education that he should be given a position at the Museum. In the meantime, Carl was busy writing — his Museum Handbook Number Three was *The Reptiles of B.C.* — and in turning his hobby of film-making into a professional asset. He produced a 400-foot colour film called *Nature's Amphibians*.

113

In the same year the Victoria Natural History Society (VNHS) was founded and Carl opened its first proceedings with a lecture on *Wildlife and Man*. He also, almost as a matter of course, became its vice-president, and later its president. In 1947, the VNHS announced a programme of lectures sponsored by the National Audubon Society. Roger Tory Peterson, then and now a celebrated naturalist, was among the first five speakers and it is recorded that "the 300 seats in Prince Robert House [which used to be on the corner of Douglas and Courtenay Streets] just wouldn't hold the crowd!"

No Time to Waste

However, reverting to 1944, by which time the war had begun to seem less threatening, Carl was urging the necessity for improvement and expansion of the Museum. His introduction to a 10-page memo to the Minister was unequivocal:

> North America is foremost in the recognition of the Museum as a powerful educational and cultural institution and development along lines to make the most effective use of the Museum has progressed rapidly in both the United States and in eastern Canada. In the past this Museum has been slow in following the others in this rapid progress so that we are much behind in this field of work. However, the possibilities are great and no time should be wasted in making it possible for this Museum to take its proper place in the life of the people of this Province.

The memo goes on to make firm recommendations for new and larger quarters, as well as a significant increase in staff to promote extension services to schools, adult education, motion-picture production and a substantial increase in field work. There was no immediate response, but this memo signalled the beginning of a steady and increasing pressure on the government to provide more resources. In the meantime, improvements to the exhibits continued. In the past, many specimens had been mounted singly, on a wooden base, with no more than a species label to identify them. Now they were grouped according to habitat and some effort, either visually or by written description, was made to indicate what kind of habitat it was.

114

The Parks Connection

*I*n 1945, Carl revived an old association with R. Yorke Edwards, working then in the Provincial Parks Division of the Forest Service, the man who was to serve as Director of the Museum from 1975 to 1984. Edwards was surveying the area now known as Manning Park, assessing its suitability as a park. "We realized," he wrote later, "there was neither the time nor the knowledge to assess fauna and flora so a cry for help went out to Cliff Carl." Carl, accompanied by George Hardy and Frank Beebe (now working for the Stanley Park Zoo), spent most of the summer on this survey, polishing his skills as a wildlife photographer, using both a still and movie camera. Edwards recalls that his growing reputation began to cause some resentment in government circles:

> Cliff's success in wildlife photography brought up some minor jealousy with the Government Travel Bureau who had an established photographer. Why couldn't or shouldn't he do the photography? Cliff made his point under a scorching Osoyoos sun! The camera man, in deep sweat, had had his camera focussed some minutes on a spade-footed toad quite happy to sit on the hot sand rather than, by means of its specialized back feet, dig into some place cool.

> "When's the — thing going to dig?" he kept asking Cliff. Cliff shrugs — who knows? After the photographer quit in disgust with a few uncomplimentary remarks about toads in general, Cliff very calmly got out a sheet of tin foil and by reflecting some sunlight onto said toad, subtly convinced it that it was becoming a really hot day and perhaps digging for cooler places was a good idea.

Cliff's success in wildlife photography brought up some minor jealousy with the Government Travel Bureau who had an established photographer.

A Borrowed and Ancient Kodak in the Pribilofs

*I*n 1946, Carl was invited to attend, as Canada's representative, an international investigation into the fur seal breeding grounds on the Pribilof Islands in Alaska. The seal population had fluctuated alarmingly since Russian explorers had discovered the herds in 1786 (the islands were named after Gerassim Pribilof, first mate of the exploration vessel *St. George*). This discovery led to a huge massacre as sealers converged on the Islands to slaughter the animals almost indiscriminately. Finally, the Russians put a stop to these activities; but in 1867, the United States purchased Alaska from the Russians and the slaughter resumed. By 1911, the remains of the seal herds, originally estimated to be composed of more than two million

115

It was on this trip that Carl refined his talents as a film-maker. He borrowed an ancient Kodak movie camera from the Forest Service and filmed the activities of the sealers, including the killing of some of the 65,000 three- year-old males taken that year.

animals, had been reduced to only 124,000. An international treaty was signed by Britain, the United States and Japan prohibiting the killing of any seals for five years except by native Indians for food and clothing. This early and enlightened act of conservation saved the seal herds of the Pribilofs from extinction. Later a quota system was introduced but, by 1946, there was anxiety that the quotas were too high; hence the international investigation Carl was invited to join.

It was on this trip that Carl refined his talents as a film-maker. He borrowed an ancient Kodak movie camera from the Forest Service and filmed the activities of the sealers, including the killing of some of the 65,000 three-year-old males taken that year. His film-making was very much a one-man operation. He was director, cameraman, scriptwriter and editor — but the resulting film was seen by many thousands of people, both in Canada and the United States. He used parts of it as one of the first subjects for his Audubon tours.

Clifford Carl (right) and Dr. V. B. Scheffer observing the seal breeding grounds in the Pribilof Islands, 1946.

(Georges Prefontaine photo)

116

In 1946, too, when he had returned from the Pribilofs, he became interested in an albino killer whale which had been sighted off Race Rocks. Because it was an albino, this was the first killer whale whose movements could be traced accurately. Carl christened it Alice, enlisting the help of lighthouse-keepers, fishermen, the Royal Canadian Mounted Police and Fisheries Patrol Vessels to report sightings, and kept a record of its movements. Thus began the gradual revision of the killer whale's unenviable reputation which, up till then it had shared with the wolf or the shark. Nowadays, we recognize them as highly intelligent creatures and many people prefer to call them orcas rather than killer whales (possibly a misguided euphemism, because one of the Oxford Dictionary's definitions of an orca is a "devouring monster, an ogre").

In 1947 Carl became president of the newly-founded Victoria Natural History Society, successor to the defunct British Columbia Natural History Society. He took this group photograph during a zoology field trip that year to Victoria's Gorge waterway.

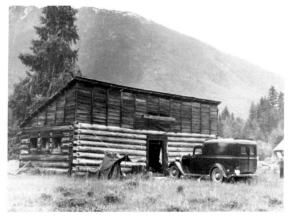

The Museum van, parked in front of a barn used as a base for field work on the old Whitworth Ranch in the Skagit Valley, 1947.

Yorke Edwards, paying tribute to Carl after his death, suggested that, "A civil servant is always, as someone put it, covered with the green mildew of discretion but Cliff did stick his neck out a number of times to complain through the press . . . 'that the Museum is totally inadequate for display purposes'."

Thunderbird Park, on the corner of Belleville and Douglas Streets, in the late 1940s. This building was later removed and Mungo Martin's Kwakiutl house replaced it.

No "Green Mildew of Discretion" Here

Yorke Edwards, paying tribute to Carl after his death, suggested that, "A civil servant is always, as someone put it, covered with the green mildew of discretion but Cliff did stick his neck out a number of times to complain through the press . . . 'that the Museum is totally inadequate for display purposes'." The first tangible results of Carl's pressure for more resources surfaced in 1948. At that time, the Museum had a staff of eight: Carl as Director; George Hardy, listed as General Assistant; A. E. Pickford, Assistant in Anthropology; Margaret Crummy, Secretary and Stenographer; Betty Newton, Assistant; Sheila Grice Davies, Typist; and Arthur Coates and E. J. Maxwell, Attendants. In May, the first university-trained biology assistant since Cowan joined the staff. He was Charles J. Guiguet, a zoologist.

The Man from Shaunavon

Charles Guiguet was born in Saskatchewan in 1916. When he was in grade eight, the Canadian Club started a natural history museum in his home town, Shaunavon, and Guiguet became involved. In 1934, his parents moved to Vancouver. After leaving school, he took a number of odd jobs, the "oddest of which was the assignment to tighten bedsprings in the new Hotel Vancouver." In the summer of 1935, he joined a field party, led by Hamilton Laing, to collect specimens on this coast for the National Museum in Ottawa. In the winter he went up to the mining camps in the Cariboo and played semi-professional hockey and basketball. He spent the next four years alternating between sport, natural history field work and university.

By then, World War II had begun and Guiguet joined the Royal Canadian Air Force in 1942, shortly after his marriage to Muriel Waller of Wells, British Columbia. He was sent overseas to serve as a Bomb Aimer in 78 Squadron. After a tour of 43 bombing sorties over Germany, he was posted to 148 Squadron, a special duties squadron in Italy, whose task was to drop supplies and agents to resistance organizations behind enemy lines, where he completed a second tour of 40 operations. Returning to the University of British Columbia after the war with the assistance of a veterans affairs grant, he earned his Bachelor of Arts degree in zoology and wildlife

118

management in 1948. His third summer as an undergraduate was spent collecting specimens for UBC in the Queen Charlotte Islands. In his final year, he worked on a joint University-Provincial Museum project, surveying the wildlife of the Goose Islands, opposite the southern tip of the Charlottes. This led to his appointment at the Museum.

By then, World War II had begun and Guiguet joined the Royal Canadian Air Force in 1942, shortly after his marriage to Muriel Waller of Wells, British Columbia.

"Divisions" Begin to Take Shape

Although Guiguet's appointment was matched by the retirement of A. E. Pickford as anthropologist, the following year saw the appointment as a temporary summer assistant in Anthropology of Wilson Duff, another university-trained addition to staff. At the same time, Guiguet was given a seven-month leave of absence to complete his graduate studies for a Master's degree at UBC. In 1949, too, the ex-laundry truck which had served as the Museum's vehicle since 1935, was replaced with a brand new truck. By 1950, Guiguet and Duff were listed as regular employees, and George Hardy had become assistant in Botany and Entomology. The eight curatorial divisions into which the Museum would eventually be divided were beginning to take shape, and field activities had begun to pick up.

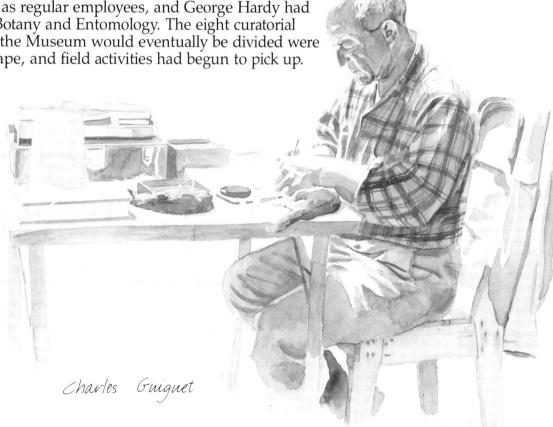

Charles Guiguet

"The Wind Was So Strong It Rolled Rocks"

In 1949, Carl, accompanied by Guiguet, Hardy and Beebe (now the curator of Stanley Park Zoo), were dropped by a fisheries vessel on Triangle Island, some 20 kilometres north of Cape Scott on the northern tip of Vancouver Island.

In 1949, Carl, accompanied by Guiguet, Hardy and Beebe (now the curator of Stanley Park Zoo), were dropped by a fisheries vessel on Triangle Island, some 20 kilometres north of Cape Scott on the northern tip of Vancouver Island. It turned out to be an adventurous trip. The *Vancouver Sun* (July 5, 1949) carried the headline: "Rare Mice, Sea Birds Found on Desolate Upcoast Island," and went on to report that the "Commander of the tiny group was Dr. C. Carl. Fighting wind and weather constantly the hardy naturalists spent seven days on the near perpendicular slopes of Triangle Island." Frank Beebe reported that a gale came through and they were situated so that the wind was funnelled into their camp. "It tore the tent loose from its moorings; you had to get down and crawl. The tent was shredded and draped on the rocks. The wind was so strong it rolled rocks. We crawled into a cave." Guiguet recalls that Carl did not find the experience exhilarating; but they were picked up a day later and, before then, Carl had found plenty of material for his film-making — material he was soon sharing with Lions, Kiwanis, Rotarians, the Natural History Society and many other organizations — while Guiguet, with his rare mice, found something he was to study for many years to come.

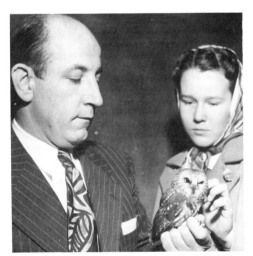

Charles Guiguet with a live Saw-whet owl and its owner, Doreen Wilbye, 1950.

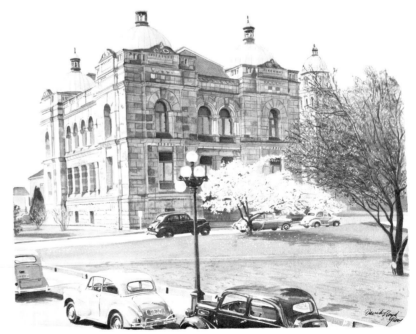

The East Wing of the Legislative Buildings

120

Wilson Duff and the Threat to Native Culture

Wilson Duff, the latest staff member to join the Museum, was born in 1925. Like Guiguet, he served as aircrew in the Royal Canadian Air Force during World War II. He began his professional career at the University of British Columbia in 1948 as an archeologist rather than an anthropologist, working with Professor Charles Borden on an experimental teaching project at the Marpole site in the delta of the Fraser River. Duff's contribution to the project was so significant, according to Borden that, "as a direct outcome of this successful conclusion, Dr. Harry B. Hawthorne [in 1947, the first anthropologist to be appointed to a university post in western Canada] recommended that UBC offer, beginning in the fall of 1949, a one-year course on the Archaeology of British Columbia."

After receiving his B.A. from UBC in 1949, Duff went on to begin graduate studies under Dr. Erna Gunther, head of the Department of Anthropology at the University of Washington. He earned his Master's degree in anthropology in 1951, the year after he had joined the Museum as a permanent staff member. Duff quickly established himself as one of British Columbia's foremost anthropologists, though at this time there appears to have been no formal division between archaeology and anthropology as disciplines. He worked with his former mentor, Professor Charles Borden, to establish a procedure that ensured any archaeological remains threatened by industrial development would be excavated and studied before the development started. As Borden puts it:

> In his capacity as a civil servant in Victoria, Wilson learned of government plans for industrial development long before public announcements were made. Such foreknowledge made possible timely co-operative planning when proposed projects threatened the obliteration of potentially important archaeological remains. Thus Wilson informed me late in 1950 of the then Liberal government's intention to grant the Aluminum Company of Canada a licence to construct a dam in the gorge of the Nechako River for the creation of a huge power reservoir in Tweedsmuir Park for the Aluminum Company's Kemano-Kitimat project. The backed-up water would flood more than 400 miles of archeologically unexplored lake and river margins. Hence, when the Alcan project was finally announced Wilson and I were ready with a joint brief to the B.C. government.

The brief was successful. In 1951, with a grant of $2,000, archaeologists carried out a preliminary site survey; a survey which revealed 130 habitation sites in the area. As a result, the government

In his capacity as a civil servant in Victoria, Wilson learned of government plans for industrial development long before public announcements were made.

made another grant of $8,000 and Alcan kicked in with an additional $5,000. "These funds," Borden records, "made it possible to mount the first large-scale archaeological rescue operation in the north central interior of British Columbia. Although severely limited in time (the excavated sites were drowned by the rising waters of the reservoir shortly after our enforced departure in September 1952) our project produced data which still figure prominently in the gradually emerging culture history of northern interior British Columbia."

With Duff on full-time staff, the future course of anthropology in the Museum was well established and in capable hands.

Guiguet demonstrating the techniques of specimen preparation for museum exhibits, 1952.

Carl, surrounded as ever by attentive students, as he explains specimen preparation in 1952.

122

The Profile Begins to Grow

*I*n 1952, Frank Beebe returned to the Museum as illustrator and technical assistant, and the *Annual Report* records that

> Early in the year, handrails were installed in the stairway leading to the basement, and the washrooms and adjoining corridors were redecorated.
>
> In June the Museum purchased a second vehicle, a Plymouth Suburban, primarily to take care of transporting lecturing equipment and for local travel.
>
> A tape-recorder was also purchased in 1952.

There was, in short, no surge of expansion during these economic boom times, but steady progress was being made. The Museum now had three university-trained scientists on staff and, because all three were gifted communicators, the Museum's profile began to grow in the public consciousness. In 1953, George Hardy, the Museum's botanist since 1941, retired. He had also served as assistant botanist from 1924 to 1928. Hardy was replaced by William A. Hubbard, a graduate of the University of Saskatchewan and the Utah State Agricultural College, and a former research-worker at the Federal Range Station at Manyberries, Alberta. But, in hindsight, perhaps the most significant appointment that year was that of a summer student assistant.

Lansdowne: Another Allan Brooks

*I*n 1951, a teenager had caught the attention of the Victoria *Times:* "A 14-year-old boy," they reported, "is being likened here by artists as another Allan Brooks — one of Canada's greatest bird illustrators. His works recently came to the attention of Dr. Carl who offered to place them on exhibition at the museum." Carl took an interest in his progress and, two years later, offered him a job as a summer assistant. Fenwick Lansdowne recalls those days with gratitude: "He was immensely kind. I was only 14 when I met him. The bird collection was in the attic and I was allowed to go up and get the skins. He gave me a summer job for two years. I spent most of my time boiling bones. And Frank Beebe, the Museum artist, gave me a great deal of helpful instruction."

In 1953, George Hardy, the Museum's botanist since 1941, retired.

George Hardy

When Lansdowne wasn't boiling bones, he was given the opportunity to accompany Guiguet and Beebe on collecting trips.

When Lansdowne wasn't boiling bones, he was given the opportunity to accompany Guiguet and Beebe on collecting trips. This gave him the chance to study the anatomical details of birds so essential for fine illustration. Thirty years later, now recognized as one of the most gifted bird illustrators in the world, Fenwick Lansdowne was back in the Museum. The Smithsonian was circulating an exhibition of his paintings, "Rails of the World," and the Museum hosted it.

Frank Beebe preparing specimens. These teaching activities by the Museum were widely reported, and applauded, by the media.

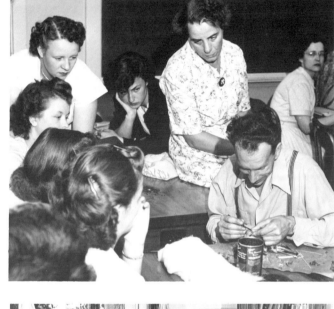

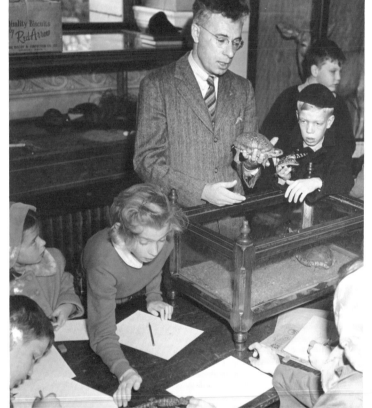

The use of live animals in a Junior Natural History Club meeting made for a large and enthusiastic membership.

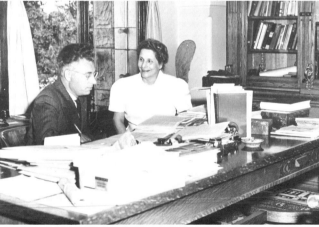

Carl and anthropologist Erna C. von Engel-Baiersdorf in Carl's office, 1952.

Carl: The Great Communicator

*I*t was in 1952, too, that Carl's first *Nature* columns appeared in the Victoria *Times,* a feature that continued unbroken until his death 17 years later. In 1954, Carl became the sole Canadian representative on the Audubon series of lectures. That spring he gave 35 programmes to more than 20,000 people. His first Audubon film was *Secrets of the Sea*. Using this film for several years, he was meanwhile preparing another called *Essence of Life*. A third feature-length film, *Pacific Patterns,* followed. Carl continued to give these lectures for 12 years. Then, in 1955, he began to participate in a CJVI weekly radio programme called *Outdoors with the Experts*. Carl co-starred with Inspector Stevenson of the Fish and Wildlife Branch, and this was another feature popular enough to continue uninterrupted for the next 12 years.

The Man from Lwow

*I*n 1955, Hubbard resigned as botanist and was replaced by Dr. Adam F. Szczawinski, another highly-qualified scientist, of whom, in describing his career, it is almost impossible to avoid a cliché: he lived a chequered existence before he joined the Museum. Educated in Poland, he obtained a degree in botany from the University of Lwow just before World War II began, and promptly had to go underground when the Russians occupied his country. As a member of the Polish resistance movement, he was arrested by the Russians. He escaped and made his way through Hungary to Yugoslavia and eventually to France, where he joined the Polish Army. He was given three weeks of training as a soldier in a cadet camp but then, just as he was ready to go into action, France collapsed and he ended up a prisoner again, this time in a German prison camp.

Once again, he was able to escape and made his way to Britain, where he became involved in the education of army personnel for the Free Polish Government in London. Next he was transferred to the headquarters of the Polish Air Force as its Director of Education. After the war, he joined the Royal Air Force and stayed with them until 1948 before deciding that a service career had little to offer. By then, he had married a young Scotswoman, Mary M. McAlpine.

In 1955, Hubbard resigned as botanist and was replaced by Dr. Adam F. Szczawinski, another highly-qualified scientist, of whom, in describing his career, it is almost impossible to avoid a cliché: he lived a chequered existence before he joined the Museum.

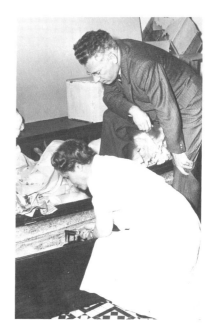

Carl and Mrs. Engel-Baiersdorf examining an Egyptian mummy. Nobody can recall what an Egyptian mummy was doing in the Museum in 1952.

125

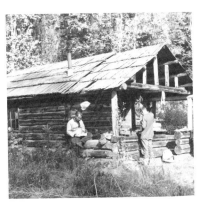

W. A. Hubbard (left) and Frank Beebe, outside their field base, Horseshoe Cabin, Wells Grey Park, 1953.

Clifford Carl (left) and Wilson Duff.

Between them they decided to come to Canada and take up farming, which seemed to offer the most likely outlet for his botanical training. Arriving in Vancouver in 1949, he bought a farm in Richmond.

From Potato Grower to Ph.D.

Szczawinski had hoped to succeed with a mixture of vegetables and flowers but neither proved profitable. After he had grown his first crop of potatoes, he discovered that he should have registered himself as a potato grower; he couldn't sell the potatoes and had to plough them under. The flowers, too, found no buyers. He had started farming without the capital to mechanize and he found the competition of the Chinese farmers too much for him. A neighbour got him a job in a cannery, looking after the boilers in the steam plant. He recalls that he had to handle the truth carelessly to get the job. His friend advised him to say that he had worked with steam machinery in Poland and on no account to admit that he had a university degree. For some six months he managed to conceal his inexperience but then, at two o'clock one morning, the superintendent of the cannery turned up at his house. The steam engineer had fallen and broken his back. Szczawinski would have to take his place — temporarily, of course, until a new engineer could be found.

Once again, he managed to avoid catastophe and returned to being a fireman when a new engineer was hired, but eventually an inspector appeared at the plant and asked to see Szczawinski's steam ticket. "Well, as a fireman," he recalls, indignantly, "I didn't know what he meant; I thought he meant a bus ticket; I didn't know you needed some ticket to run the stupid boiler." The inspector was sympathetic, but he insisted that Szczawinski would have to have his steam ticket before the next inspection, which might occur any time in the next six months.

Szczawinski decided it was time to move on. He went to the University of British Columbia and enrolled on a Doctorate of Philosophy programme in botany. The next three years were lean ones — survival depended on part-time jobs in grocery stores — but he finally graduated with his doctorate, the first Ph.D. in botany ever awarded by the university, in 1953. For the next two years he

worked as a lecturer at UBC before his appointment at the Museum in 1955. He quickly joined the lecture circuit — the records show that he gave 72 lectures in one year — and began to publish, not for an exclusive academic readership but for the general public. His *Guide to Common Mushrooms of British Columbia*, co-authored with R. J. Bandoni in 1964, became a best seller among the Museum's publications and is still much in demand. He was also, as we shall see later, a very provocative public speaker.

More Significant Appointments

There had, however, in 1953, been three other significant appointments to the staff. Thunderbird Park, created in 1941 as a showplace for the totem-pole carver's art, had been an outstanding success. But now, a dozen or so years later, it became evident that the poles on display were deteriorating. Conservation techniques developed by that time could have slowed the process but not arrested it. Eventually, the precious legacy of the totem poles would have been doomed to decay and disintegration. Between them Carl and Duff came to the conclusion that the only certain method of conservation was to store the poles indoors in a controlled environment. This left the obvious problem of what to display in Thunderbird park. The solution was at once simple and inspired: hire carvers to duplicate the poles and erect the duplicates in the Park. This had the double merit of conserving the old and helping to revive an art that was in danger of dying out.

A large, cedar carving shed was erected to the west and immediately adjacent to the Park and Mungo Martin, a celebrated Kwakiutl artist (at 72, one of the few totem-pole carvers still available), his son Martin and Henry Hunt were appointed as the Museum's carvers. They, and their successors, have carved poles ever since, often travelling to Europe to demonstrate their art.

By the end of the '50s, the staff had grown to 14 and a separate book would be required to record all their activities. Michael Kew, B.A., who had been an anthropology assistant since 1956, left and was replaced by Diane MacEachern, B.A. Don Abbott, B. A., joined her as an anthropology assistant in 1960. In addition to Frank Beebe and Betty Newton, Sheila Newnham was listed as a technician. The purse strings were loosening (though not dramatically: the total

His (Szczawinski's) Guide to Common Mushrooms of British Columbia, co-authored with R. J. Bandoni in 1964, became a best seller among the Museum's publications and is still much in demand.

Frank Beebe

127

A large, cedar carving shed was erected to the west and immediately adjacent to the Park and Mungo Martin, a celebrated Kwakiutl artist (at 72, one of the few totem-pole carvers still available), his son David and Henry Hunt were appointed as the Museum's carvers.

budget, including salaries, for 1958 was $72,760) and staff were able to travel rather more frequently, both for scientific collecting and to attend seminars and programmes of professional development. Most became involved in other organizations: Carl, among many other directorships, became President of the British Columbia Museums Association (BCMA) in 1959; Duff was Chairman of the Archaeological Sites Advisory Board and later President of the BCMA; Szczawinski was elected member-at-large of the Canadian Botanical Organization; and Guiguet, while apparently less of an organization man, was maintaining a high profile with his publications and his expertise in hunting and fishing. All, it seemed, had the gift of combining sound scientific research with the ability to communicate their knowledge to the general public.

The celebrated Indian carver, Mungo Martin (right) and his son David, work on what came to be the world's tallest totem pole, later erected in Beacon Hill Park.

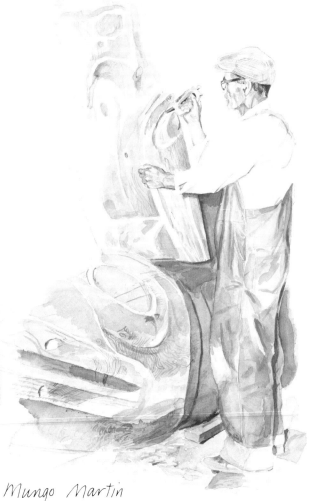

Mungo Martin

128

Publications and Programmes

This was a fertile era for publications, most of them designed for the general public. In the 12 years from 1952 to 1964, 24 titles were published in the Handbook Series, starting with George Hardy's *Fifty Edible Plants of B.C.* and ending with Szczawinski and Bandoni's *Some Common Mushrooms of B.C.* In addition, there were another 14 titles in the Occasional Paper Series, two in Special Publications and 10 under the heading of Anthropology.

School programmes in particular at this time drew a great deal of media attention, and the staff went to remarkable lengths to make the study of natural history interesting to young people. Displays of plants, freshly harvested every week, were part of the curriculum. Live creatures — rattlesnakes, frogs and other amphibians — were on display, as was a live bee colony with a small corridor leading to the open air. Many people, no longer young, can recall spending hours of their childhood watching the bees performing their small miracle of collective social responsibility. Yet still there remained the over-riding problem of space — or rather, the lack of it. This lack precluded any further attempts to introduce innovative display techniques. Already, there was an almost claustrophobic density of specimens and artifacts.

Many people, no longer young, can recall spending hours of their childhood watching the bees performing their small miracle of collective social responsibility.

And no child could fail to experience the thrill, and chill, engendered by a live snake.

Children in the 1950s spent many hours watching bees perform their small miracle of collective social responsibility.

This was an interesting development: a biologist proposing what were later to be called modern history exhibits in the Museum.

The government responded by suggesting a second move into the Bastion Square courthouse, then being replaced by new and larger premises. In a *Daily Colonist* article (October 16, 1959), Alec Merriman pointed out that "The Provincial Museum is bursting at its seams and thousands of specimens that could be displayed for the benefit of all British Columbia are hidden away in dusty attics and unused rooms of the legislative buildings. 'We have no working space and no proper laboratory. The housing we now have is totally inadequate,' museum director Dr. Clifford Carl said yesterday." The article went on to quote Carl as saying that "the old Victoria courthouse which will soon be replaced by a new courthouse is not the answer for a museum. A museum is a modern institution requiring a highly specialized modern building." Guiguet, too, was quoted as visualizing "a multi-storey building with miniature working models of oil wells, model pulp and timber mills and other displays featuring agriculture, fishing and other resources as well as displays of the historical past now partially on show in the provincial archives."

This was an interesting development: a biologist proposing what were later to be called modern history exhibits in the Museum. Much of what Guiguet suggested came to pass eventually, even though the models never turned out to be working models. Fortunately, a reluctant government was now being bombarded with requests for a new museum. Vancouver Island Mayors gave blanket support. The Natural History Society appealed to Premier Bennett, and staff kept up the pressure.

Wilson Duff

Politics: A Time of Challenge and Tension

*A*dam Szczawinski recalls it as a time of challenge and tension. In 1959, he came close to losing his job. Although it was an area not directly concerned with the Museum, he had become involved in a movement to persuade the government to start preserving some wilderness areas in the province. The necessity for them had become obvious and derived from his studies at the Museum and he decided to speak out on the issue. For, "I felt very strongly that British Columbia in those days was at least 50 years behind in this vital aspect of conservation. We could see what had happened in Europe, and I thought that Canada, and particularly British Columbia, was in an excellent position to learn from those mistakes."

Szczawinski persuaded Dr. David B. Turner, then Deputy Minister of Recreation and Conservation, to accompany Guiguet and himself to the Cassiar mountains, an area he regarded as a prime one for a wilderness reserve. They spent three weeks on their survey; after which, encouraged by Turner, Szczawinski prepared a report to the government, pointing out that there was some urgency because this was a fragile environment; its caribou herds and other game animals were being rapidly depleted and the alpine vegetation was particularly vulnerable. Before he submitted the report, however, he gave a public lecture, sponsored by the Natural History Society — a lecture in which he was critical of the government for not already having created this as a wilderness area or an ecological reserve.

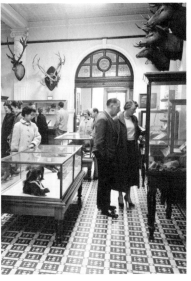

The East Wing in the early 1960s. Botanist Adam Szczawinski is in the centre of the photograph above, profiled with his pipe in his mouth.

"Provincial Botanist Muzzled by Premier"

*U*nfortunately for Szczawinski, a Swedish financier called Axel Wenner-Gren, who was very much in favour with the government at the time, was interested in precisely the same area: he wanted to exploit the mineral reserves. Thus, the following day, the newspapers picked up on the story. There was an editorial in the *Times*. Next the Canadian Broadcasting Corporation took up the story and finally Ottawa newspapers carried it. Szczawinski recalls the episode with some satisfaction:

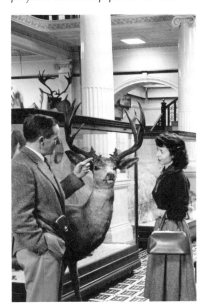

*Then one day, Dr. Turner
and Dr. Carl came into
my office. They told me
they had a message from
Mr. Bennett [the late
W. A. C. Bennett].
If I didn't keep my mouth
shut, I wouldn't need it
any more round here —
I would be fired.*

Dr. Adam Szczawinski

This was in 1959, and I was very proud that I had poured enough oil into the fire. Everybody was interviewing me; everybody was talking about wilderness areas. Then one day, Dr. Turner and Dr. Carl came into my office. They told me they had a message from Mr. Bennett [the late W. A. C. Bennett]. If I didn't keep my mouth shut, I wouldn't need it any more round here — I would be fired.

Sczawinski complained with some justification that only a few days previously Turner and Carl had encouraged him to press for ecological reserves. Now they were threatening to fire him. There was, he recalls, a long silence, after which they left his office. Szczawinski promptly contacted the media again and there followed more headlines about "Provincial Botanist Muzzled by Premier." The government, no doubt wanting to cool the issue, took no action. Eventually, however, Szczawinski was summoned to see the Premier.

He wanted to see how the devil looked, so he asked Laurie Wallace [Deputy Provincial Secretary] to bring me to his office. I was pretty nervous, but when we got to his office, he rushed to greet me, patted me on the back. "First of all let me tell you that we are delighted to have someone like you in the Civil Service. Your minister and my colleagues tell me you are doing a fantastic job. We're delighted to have someone so dedicated in the Museum."

And I said, "Museum? you call that a museum? Sir, you know that it's time British Columbia had a proper museum."

"Bennett O.K.'s New Museum"

Premier Bennett must have had to call on all his reserves of self-control. But one senses that the government had come to admire Szczawinski's refusal, on a matter of principle, to buckle under. Perhaps they had also come to realize that the Museum's curators could no longer be dismissed as dry, dusty-fingered academics or irritating eco-freaks. Instead, they now had considerable public support. In any case, instead of exploding, Bennett assured Szczawinski that the government was doing everything it could to see that a new museum would be created in the not too distant future. And so it turned out. In 1963, the *Colonist* carried the headline: "New Museum, Archives Pledged in Two Years." The *Times* matched it with "Bennett O.K.'s New Museum Go Ahead."

132

In fact, by this time the decision should have been old news. In a memo dated October 1961, to Earle Westwood, his Minister at the time, Carl pointed out that, "Since the Premier has already made a public announcement that a new building is to be planned for us would it not be in order for him to focus his attention our 75th anniversary in 1962 by a further announcement that the planning phase had actually started." This suggests that Bennett's earlier announcement was probably equivocal, and that Carl was hoping to pin him down to a more definite one.

The $3,000,000 Plan

But once the government had committed itself, the plans seemed adequate if not overwhelming. The original estimate for the proposed complex was $3,000,000, not a large sum even in 1960s' dollars. However, soon after the announcement, a Steering Committee and a Planning Committee were set up, "the first to set policy and to act as a guide, the second to develop plans". In July,

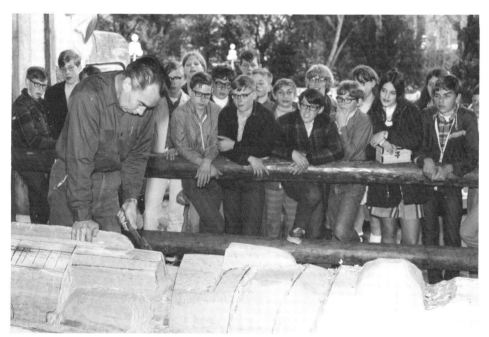

Another celebrated Indian artist, Henry Hunt, carving a totem pole in the carving shed.

Modelmaker John Smyly (left), who was to remain with the Museum for another 22 years and produce many outstanding scale models for the developing permanent exhibits, and exhibits designer Erik Thorn in 1966.

1964, five members of the Planning Committee, representing both the architectural division of the Department of Public Works and the Museum, made a tour of museums, art galleries and other public buildings. A sixth member, Provincial Archivist Willard Ireland, joined them in Ottawa. Altogether, they visited 17 institutions in San Francisco, Berkeley, Denver, Toronto, Ottawa, Milwaukee, Helena and Spokane. Then the government announced that it was going to build the new complex on the summit of Beacon Hill Park. It made the mistake of pointing out that this would allow for unlimited parking and unlimited future expansion. Victorians are very proud of their park and public reaction was vociferous enough to put an end to that scheme almost immediately. The next move was an announcement that the new museum complex was to be a joint federal-provincial Canadian Centennial project, and that it would consist of an archives building, a museum exhibits building and a curatorial tower, all to be located on the vacant half block, owned by the government and then being used as a parking lot, on the east side of Government Street, directly across the road from the East Wing of the Legislative Buildings.

An artist's impression of the forthcoming new Museum.

*T*here followed, for the staff, a period of intensive activity. In 1965, Wilson Duff resigned to move to a teaching post at the University of British Columbia. Don Abbott was appointed Acting Curator of Anthropology to replace him. Eric Thorne was appointed Chief of the Display Division; John Smyly as a technician; Michael Miller as a student taxidermist; Robert Nichols as field agent; John Sendey as an assistant; and Peter Macnair as an assistant in anthropology. John Sendey had been hired to supervise the transferring of the Archives artifact collection to the Museum. For Clifford Carl the burden must have been particularly heavy. When construction officially started in May, 1965, the government had already revised its original estimate of costs from three million to eight million dollars. Guiguet recalls that these figures seemed to overawe Carl. "He was a child of the Depression; he couldn't seem to believe that so much money really could be made available for a museum."

Dr. Clifford Carl

For Clifford Carl the burden must have been particularly heavy.

Clifford Carl receiving an award for his services from Premier W. A. C. Bennett, 1965.

Premier W. A. C. Bennett presides at the Ground Breaking Ceremony for the new Museum project on May 6, 1965.

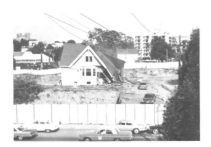

The project began with the removal of a house on the new Museum site.

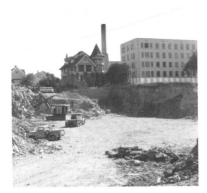

Excavation began in September, 1965.

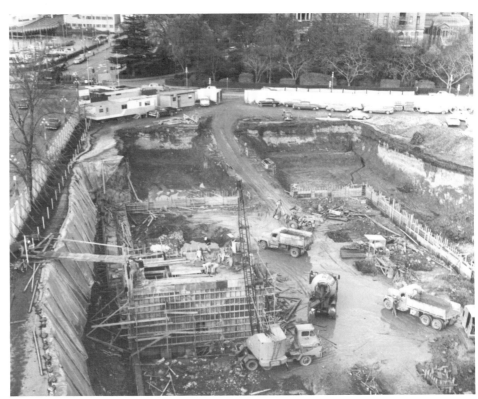

By the end of November, construction was underway. The Empress Hotel can be seen in background.

The main exhibits building takes shape.

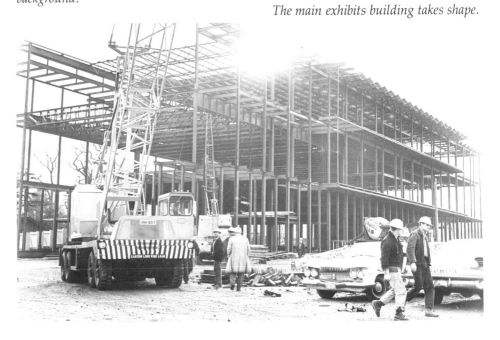

Planning Instead of Performing

*I*n truth there were many things that Carl had perhaps not visualized when he was striving for a new museum. One of the first, and obvious, effects was that he had to curtail some of his lecturing activities and devote far more time to administration and planning. By 1965, the staff list in the *Annual Report* had climbed to 20. In that same year, Carl applied for permission to attend Bicentennial celebrations at the Smithsonian Institute. The response from the Deputy Minister was, perhaps, predictable:

> While we recognize the importance of the Washington, D.C. meetings, we feel that, as Museum Director, you must curb more than travel to conferences for the next year or two. You must eliminate extra-curricular activities henceforth until such time as the new Museum is opened and operated. This elimination particularly applies to lecture activities such as the Audubon tours and University of Victoria lecture series. Your duties in organizing the new Museum complex are and will be increasingly onerous in the months ahead.

There is an irony here. Some people had criticized Carl for being too eager to be a media star, while neglecting his research activities. Such people clearly failed to appreciate that the functions of a museum director had changed considerably since the Kermode days. It was no longer sufficient to live in the insular precincts of the museum, communicating only with the museum and academic communities, and only in their often esoteric language. A director now had to communicate the results of his museum's research and other activities to the general public — in language that would catch the general public's interest — because only then would the public provide the kind of support necessary to fund a modern museum, knowing that they would benefit from it. Carl had succeeded brilliantly in this task; now he had to realize that the next evolving role for a museum director was to leave much of the communication to his staff, while he himself concentrated on pure planning and administration. With considerable regret, he curtailed his lecturing activities, hoping no doubt to resume them when the new Museum was completed.

Some people had criticized Carl for being too eager to be a media star, while neglecting his research activities.

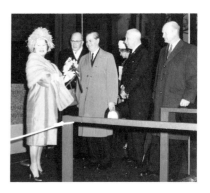

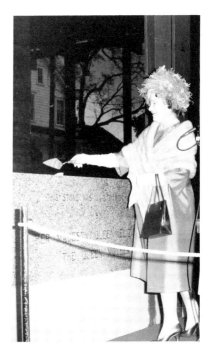

(Above): Her Majesty, Elizabeth the Queen Mother, participates in a cornerstone-laying ceremony on March 19, 1966. With her (from left to right) Honourable W. N. Chant, Premier W. A. C. Bennett, His Honour, Lieutenant-Governor George Pearkes and Deputy Provincial Secretary L. J. Wallace.
(Below): Her Majesty wields the trowel.

The new complex, called Heritage Court, was opened by Premier W. A. C. Bennett on August 16, 1968, a year late for the centenary of Canadian Confederation, and finally costing $9,500,000, of which the federal government had provided $2,500,000.

A Museum at Last

The new complex, called Heritage Court, was opened by Premier W. A. C. Bennett on August 16, 1968, a year late for the centenary of Canadian Confederation, and finally costing $9,500,000, of which the federal government had provided $2,500,000. But while the public celebrations were taking place, Museum staff were facing some awesome problems. For years they had dreamed and yearned for more space. Now, faced with what seemed like acres of exhibition space, they found themselves at a loss. In spite of countless meetings and planning sessions, they had failed so far to formulate any unifying concept, any overall theme to tie the different exhibits together.

Although the curatorial tower — the Fannin Building — in the background was still under construction, the new Museum opened on August 16, 1968. (Above, left to right) Premier W. A. C. Bennett, Federal Consumer Affairs Minister Ron Basford and Deputy Provincial Secretary L. J. Wallace.

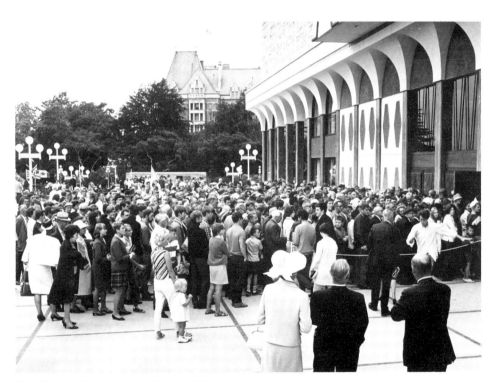

The first visitors to enter the new Museum.

Carolyn Case, who had joined staff as the first Modern History Curator, was faced with perhaps the most difficult task. The collection of artifacts for modern history recently handed over by the Archives, and which we have already described as eclectic, did not lend themselves to any particular theme or storyline. The planned new natural history dioramas were taking far more time and resources to produce than anticipated. The ethnology exhibit lacked cohesion and continuity. A Victoria *Times* article of August 17, describing the opening ceremonies, reflected the difficulties when it pointed out that, "The building itself seemed to make a clearer initial impression than the display content which is still being arranged and enlarged." There was more criticism to come. Complaints about aesthetic shortcomings of the Lionel Thomas carving of the Nootka whaling scene in the Foyer, both by Museum staff and the general public, appeared in the press, as well as public complaints about uninspired displays.

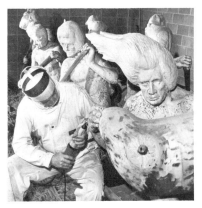

Artist Lionel Thomas carving the Nootka whaling scene.

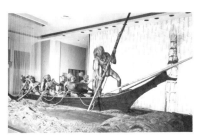

The completed whaling scene in the foyer of the new Museum with the rain curtain behind its stern.

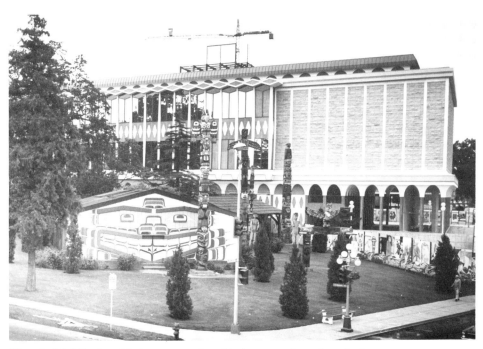

Thunderbird Park, with its totem poles, big house and carving shed.

139

. . . the story of the Museum since 1968 has been told in The Ring of Time *(BCPM, 1985), a companion volume to this book.*

The Ring of Time

*B*ut the story of the Museum since 1968 has been told in *The Ring of Time* (BCPM, 1985), a companion volume to this book. In that book we could end on a note of celebration; here we must end on a note tinged with sadness. For in spite of the seeming realization of all his dreams, the culmination of all his dedicated work — the new Museum — Clifford Carl did not live to see what he and his small staff had really laid the foundations for — a museum with an international reputation for excellence. After 30 years of a workload that would have crushed most people, he resigned as Director in December, 1969, and became Curator of *The Hall of the Sea,* a marine biology display to fill some of that yawning space. Four months later he was dead, a victim of leukemia.

He left us an admirable legacy and his successors, Bristol Foster and Yorke Edwards, led the Museum through the difficulties and complexities of new and vastly enlarged exhibit galleries to the success of the '70s and '80s. Now Bill Barkley who, in 1984, became the Museum's sixth director, has the task of leading us into the second century of accomplishment.

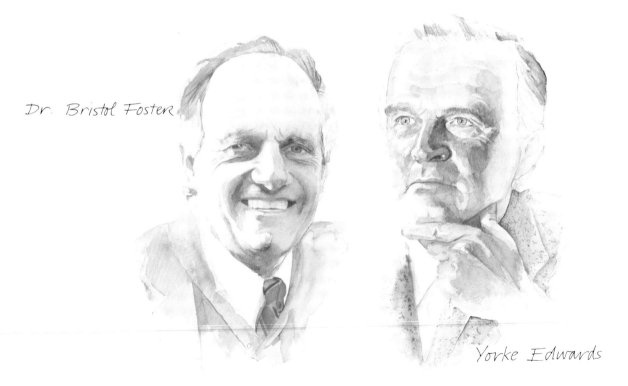

Dr. Bristol Foster

Yorke Edwards

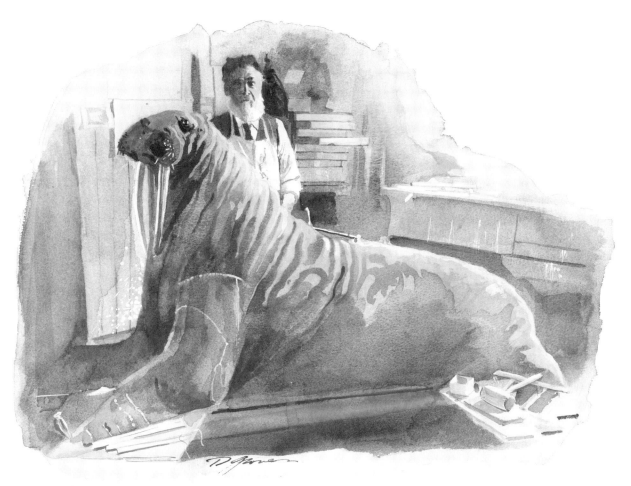

John Fannin preparing a walrus for display.

Appendix

To His Honour

The Lieutenant Governor in Council

re A Provincial Museum

May it Please Your Honour

It has long been felt desirable that a Provincial Museum should be established in order to preserve specimens of the natural products and Indian Antiquities and Manufactures of the Province and to classify and exhibit the same for the information of the public.

It is a source of general regret that objects connected with the ethnology of the country are being yearly taken away in great numbers to the enrichment of other museums and private collections while no adequate means are provided for their retention in the province. Limited as such articles are in quantity their loss is frequently irreparable, and, when once removed from the locality of their production, their scientific value and utility to the country are greatly lessened.

There is no doubt that the recent opening up of British Columbia by railway enterprize will stimulate the development of her mineral and other natural resources; hence, a museum where classified specimens of ores, etc., may be examined, will prove of practical benefit to the Province at large. It is an acknowledged fact that the Natural History of the country is by no means as yet perfectly understood, and it is trusted that if a centre for investigation be afforded, the interests of that science will be advanced, and the attention and cooperation of naturalists of other countries will be gained.

There are at present in the Province many gentlemen interested in furthering this scheme who have signified their readiness to assist to the best of their powers.

At a meeting, held for the purpose of considering this subject, upon Thursday, Jan. 14th it was resolved to memorialize Your Honour in Council, praying that such steps may be taken by the Government towards establishing the proposed Institution as may be considered requisite.

And your Petitioners, as in duty bound, will ever pray & e.

The Petition was signed by the following:

M. B. Begbie	W. S. Gore
G. Columbia	J. W. Higgins
I. N. Powell	J. Davies
R. P. Rithet	C. Wilson
E. Crowe Baker	J. Ash
N. Shakespeare	A. H. Green
H. P. Crease	W. F. Tolmie
C. E. Pearse	R. Ward
R. Harvey	A. Scrivenor
J. Fall	J. H. Gray
W. C. Ward	R. L. T. Galbraith
A. J. Langley	J. A. Mara
J. S. Knevette de Knevette	C. A. Semlin
P. Jenns	T. Harper
G. Walkem	B. W. Pearse

The Lieutenant Governor forwarded the Petition to the Executive Council under this memorandum:

Government House
January 29th, 1886

In referring to the accompanying Petition on the subject of the establishment of a Provincial Museum to the Executive Council the Lieutenant Governor fully appreciates and can conscientiously emphasize the arguments and reasons therein set forth why such an institution is desirable, and confidently recommends it to the favourable consideration of the Council.

Clement Cornwall

It will be observed that the Petition has received the signatures of the most prominent persons, scholars or otherwise, in the place.

Index

A

Abbott, D., 127, 135
Aberdeen, United Kingdom, 34
Alaska, U.S.A., 71, 115
Aluminum Company of Canada, 121
American Museum of Natural History, 36, 37, 52, 68, 86
Anderson, J. R., 33
Anderson, E. M., 51, 52, 58, 64, 65, 77
Anscomb, H., 112
Anthropology, 17, 20, 34, 37, 43, 47, 48, 52, 57, 58, 67, 68, 78, 82, 87, 93, 95, 109, 113, 118, 119, 121, 122, 127, 129, 135
Archaeology, 31, 33, 51, 68, 121, 122, 128
Archives: *see* Provincial Archives of British Columbia
Atlin, British Columbia, 58, 77, 87

B

Bandoni, R. J., 127, 129
Banks, J., 18
Barkley, W., 140
Barkerville, British Columbia, 21
Bastion Square, 26
Beacon Hill Park, 56, 134
Beanlands, A., 27
Beebe, F. L., 111, 112, 115, 120, 123, 124, 127
Begbie, Judge Matthew, 17, 32, 138
Bennett, W. A. C., 130, 132, 133
Bennett, R. B., 83
Berkeley, California, 73, 86, 89, 134
Biology, 33, 34, 43, 49, 50, 62, 66, 69, 70, 72, 77, 78, 79, 81, 82, 83, 85, 86, 87, 90, 91, 93, 94, 98, 107, 108, 118, 130, 140
Biological Survey of U.S., 49, 57, 66, 72
Biological Station, Nanaimo, 99
Blackmore, E. H., 64, 65, 69
Boas, Franz, 28, 33, 36, 68
Borden, C., 121-122
Botany, 17, 33, 35, 36, 69, 86, 111, 113, 119, 123, 125, 126, 128

Bowser, W. J., 62
British Columbia, 17–19, 19, 21, 26-27, 30-31, 33, 35, 37, 39-40, 45, 47, 51-52, 54-55, 57, 61, 64, 68, 70, 72, 85-86, 94, 96, 91–101, 107, 111, 113, 118, 121-122, 126–128, 130–132, 135
British Columbia Department of Education, 86, 111, 113
British Columbia Department of Recreation and Conservation, 111, 131
British Columbia Department of Public Works, 111, 134
British Columbia Forestry Service, 113, 115-116
British Columbia Government, 47, 94-95, 102, 134
British Columbia Museums Association, 128
British Columbia Provincial Library, 86, 94-95, 102
British Columbia Provincial Museum, 17-18, 20-21, 26-27, 32–34, 37–40, 43–52, 54, 57, 59, 64–69, 72, 73, 77–79, 81, 83-84, 86–88, 90–95, 98–101, 103, 107–115, 118-119, 121–125, 127, 130–132, 134-135, 137–140
British Columbia Provincial Police, 101-102
British Museum, 52-53
Brooklyn Museum of Arts and Sciences, New York, 52
Brooks, A., 72-73, 90, 123
Burrard Inlet, British Columbia, 24-25, 72
Butler, F. R., 108

C

Cape Calvert, British Columbia, 58
Canada, 34, 49, 63
Canada, Government of, 62, 83, 86, 123, 134, 138
Canadian Club, 118, 131
Canadian Broadcasting Corporation, 86, 131
Cariboo District, British Columbia, 21, 20, 118
Caribou, Queen Charlotte Islands, 40, 50-51, 68, 91, 131

Photograph Credits

Sources:

British Columbia Government
Royal British Columbia Museum
Provincial Archives of British Columbia
Public Archives of Canada
E. Hembroff-Schleicher
Vancouver City Archives
Georges Prefontaine

PRINTED IN CANADA BY MANNING PRESS